D1271628

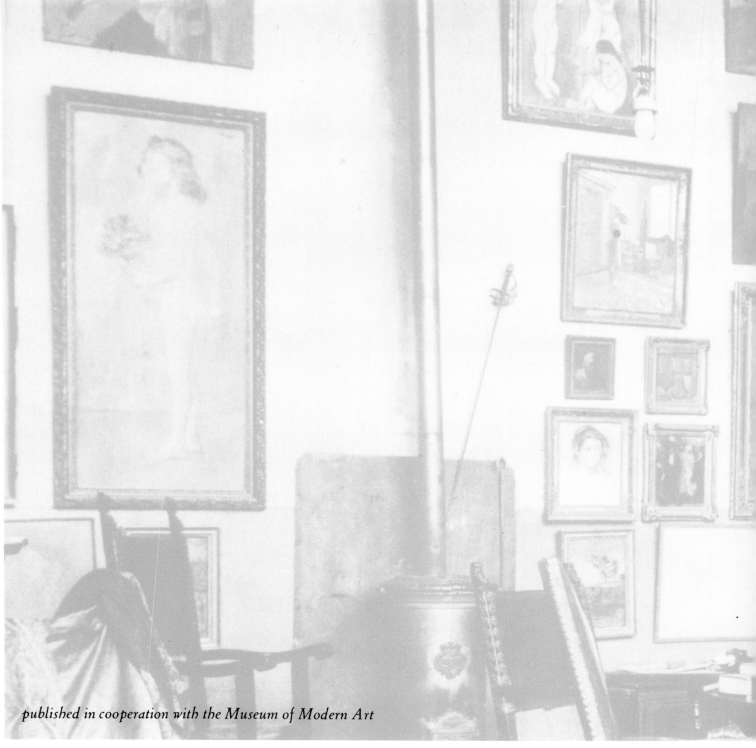

published in cooperation with the Museum of Modern Art

ND
553
.P5
S76

WITHDRAWN

GERTRUDE STEIN ON PICASSO

Edited by Edward Burns

Afterword by Leon Katz and Edward Burns

LIVERIGHT NEW YORK

Copyright © 1970 by Liveright Publishing Corporation
"From the Notebooks" copyright © 1970 by the Estate
of Gertrude Stein
All rights reserved. No part of this book may be
reproduced in any form without permission in
writing from the publisher.

1.987654321

Picasso, originally published by B. T. Batsford,
Ltd., London, is reprinted here by permission of the
Estate of Gertrude Stein.

"Picasso" is reprinted from Selected Writings of
Gertrude Stein. Copyright 1946 by Random House,
Inc. Reprinted by permission of the publisher.

"If I Told Him: A Completed Portrait of Picasso" is
reprinted from Portraits and Prayers by Gertrude Stein.
Copyright 1934 and renewed 1962 by Alice B. Toklas.
Reprinted by permission of Random House, Inc.

"From the Notebooks" is first published here with
permission of the Estate of Gertrude Stein and the
Yale University Library.

Standard Book Number: 87140-513-X
Library of Congress Catalog Card Number: 78-131273

Designed by BETTY BINNS

Type set by YORK TYPESETTING CO., INC.
Printed by HALLIDAY LITHOGRAPH CORP.
Color printed by THE LEHIGH PRESS, INC.
Bound by SENDOR BINDERY, INC.

Manufactured in the United States of America

CONTENTS

Picasso (1938)

3

Picasso (1909)

79

If I Told Him: A Completed Portrait
of Picasso (1923)

83

From the Notebooks

95

30501

PICASSO

Painting in the nineteenth century was only done in France and by Frenchmen, apart from that, painting did not exist, in the twentieth century it was done in France but by Spaniards.

In the nineteenth century painters discovered the need of always having a model in front of them, in the twentieth century they discovered that they must never look at a model. I remember very well, it was between 1904–1908, when people were forced by us or by themselves to look at Picasso's drawings that the first and most astonishing thing that all of them and that we had to say was that he had done it all so marvellously as if he had had a model but that he had done it without ever having had one. And now the young painters scarcely know that there are models. Everything changes but not without a reason.

When he was nineteen years old Picasso came to Paris, that was in October 1900, into a world of painters who had completely learned everything they could from seeing at what they were looking. From Seurat to Courbet they were all of them looking with their eyes and Seurat's eyes then began to

3

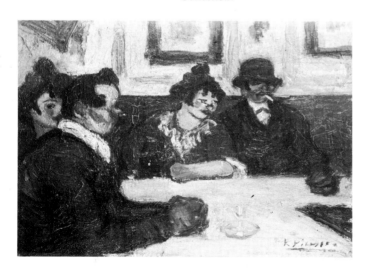

CAFE SCENE, *Paris, 1900, Oil. Yale University Library, Gertrude Stein Collection.*

tremble at what his eyes were seeing, he commenced to doubt if in looking he could see. Matisse too began to doubt what his eyes could see. So there was a world ready for Picasso who had in him not only all Spanish painting but Spanish cubism which is the daily life of Spain.

His father was professor of painting in Spain and Picasso wrote painting as other children wrote their a b c. He was born making drawings, not the drawings of a child but the drawings of a painter. His drawings were not of things seen but of things expressed, in short they were words for him and drawing always was his only way of talking and he talks a great deal.

Physically Picasso resembles his mother whose name he finally took. It is the custom in Spain to take the name of one's father and one's mother. The name of Picasso's father was Ruiz, the name of his mother was Picasso, in the Spanish way he was Pablo Picasso y Ruiz and some of his early canvases were signed Pablo Ruiz but of course Pablo Picasso was the better name, Pablo Picasso y Ruiz was too long a name to use as a signature and he commenced almost at once to sign his canvases Pablo Picasso.

The name Picasso is of Italian origin, probably originally they came from Genoa and the Picasso family went to Spain by way of Palma de Mallorca. His mother's family were silversmiths. Physically his mother like Picasso is small and robust with a vigorous body, dark-skinned, straight not very fine nearly black hair; on the other hand Picasso always used to say his father was like an Englishman of which both Picasso and his father were proud, tall and with reddish hair and with almost an English way of imposing himself.

The only children in the family were Picasso and his younger sister. He made when he was fifteen years old

4

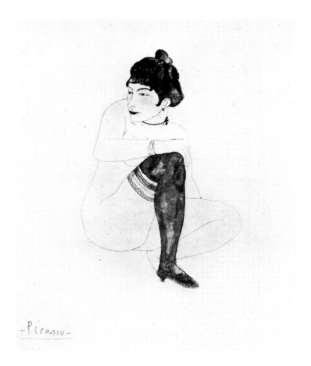

SEATED NUDE WITH GREEN STOCKING,
*Barcelona, 1902, Watercolor. Private
Collection, Paris.*

oil portraits of her, very finished and painted like a born painter.

Picasso was born in Malaga the 25th of October 1881, but he was educated almost entirely in Barcelona where his father until almost the end of his life was professor of painting at the academy of Fine Arts and where he lived until his death, his mother continued living there with his sister. She has just died there.

Well then, Picasso at nineteen years of age was in Paris, where, except for very rare and short visits to Spain, he has lived all his life.

He was in Paris.

His friends in Paris were writers rather than painters, why have painters for friends when he could paint as he could paint.

It was obvious that he did not need to have painters in his daily life, and this was true all his life.

He needed ideas, anybody does, but not ideas for painting, no, he had to know those who were interested in ideas, but as to knowing how to paint he was born knowing all of that.

So in the beginning he knew intimately Max Jacob and at once afterwards Guillaume Apollinaire and André Salmon, and later he knew me and much later Jean Cocteau and still later the Surréalistes; this is his literary history. His intimates amongst the painters, and this was later, much later than Max Jacob and than Guillaume Apollinaire and than André Salmon and than I, were Braque and Derain, they both had their literary side and it was this literary side that was the reason for their friendship with Picasso.

The literary ideas of a painter are not at all the same ideas as the literary ideas of a writer. The egotism of a painter is entirely a different egotism than the egotism of a writer.

The painter does not conceive himself as existing in

5

himself, he conceives himself as a reflection of the objects he has put into his pictures and he lives in the reflections of his pictures, a writer, a serious writer, conceives himself as existing by and in himself, he does not at all live in the reflection of his books, to write he must first of all exist in himself, but for a painter to be able to paint, the painting must first of all be done; therefore the egotism of a painter is not at all the egotism of a writer, and this is why Picasso who was a man who only expressed himself in painting had only writers as friends.

In Paris the contemporary painters had little effect upon him but all the painting he could see of the very recent past profoundly touched him.

He was always interested in painting as a metier, an incident that happened once is characteristic. In Paris there was an American sculptress who wished to show her canvases and sculpture at the salon. She had always shown her sculpture at the salon where she was *hors concours* but she did not wish to show sculpture and painting at the same salon. So she asked Miss Toklas to lend her her name for the pictures. This was done. The pictures were accepted in the name of Miss Toklas, they were in the catalogue and we had this catalogue. The evening of the *vernissage* Picasso was at my house. I showed him the catalogue, I said to him, here is Alice Toklas who has never painted and who has had a picture accepted at the salon. Picasso went red, he said, it's not possible, she has been painting in secret for a long time. Never I tell you, I said to him. It isn't possible, he said, not possible, the painting at the salon is bad painting, but even so if any one could paint as their first painting a picture that was accepted, well then I don't understand anything about anything.

Take it easy, I said to him, no she didn't paint the picture, she only lent her name. He was still a little troubled,

In the studio of the rue de Fleurus, circa 1905.

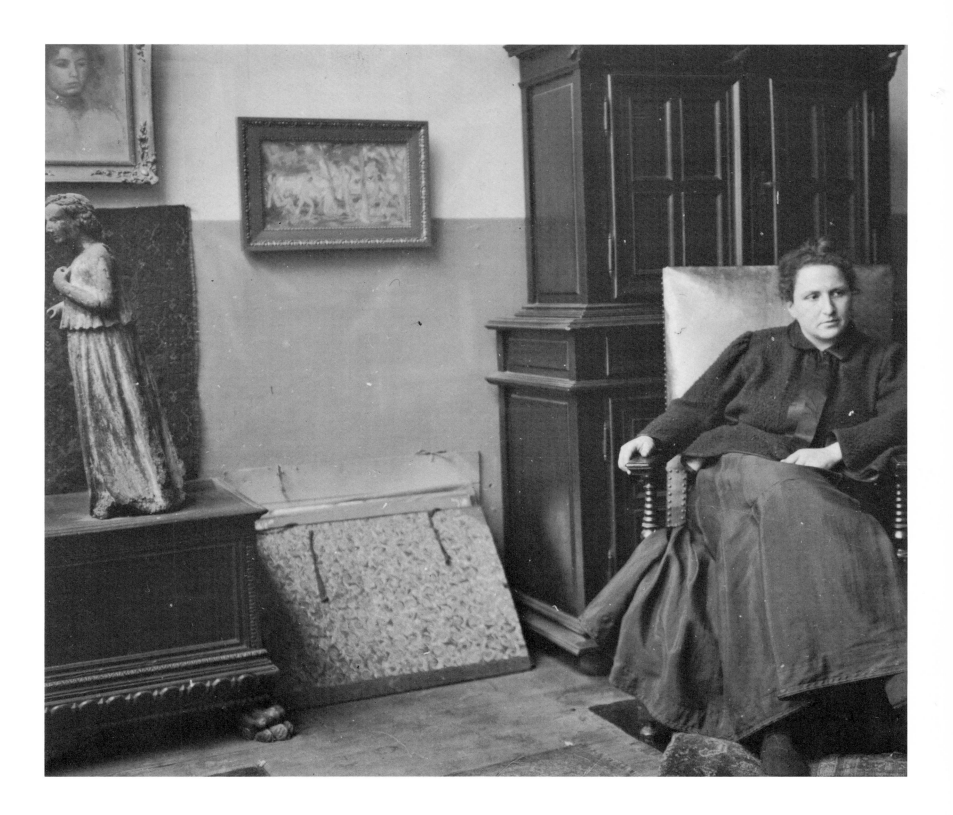

THE BLUE HOUSE, *Barcelona, 1902,*
Oil. Collection Mr. André Meyer,
New York.

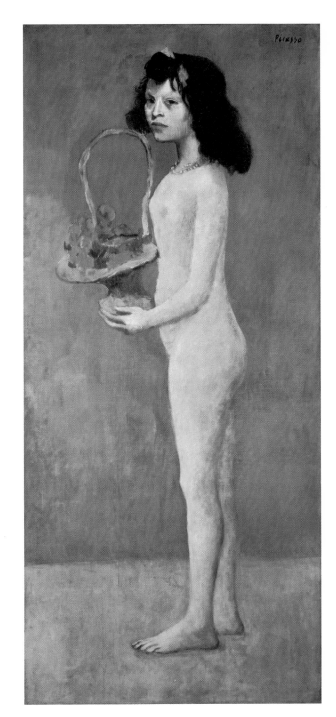

GIRL WITH A BASKET OF FLOWERS,
*Paris, 1905, Oil. Collection Mr. and
Mrs. David Rockefeller, New York.*

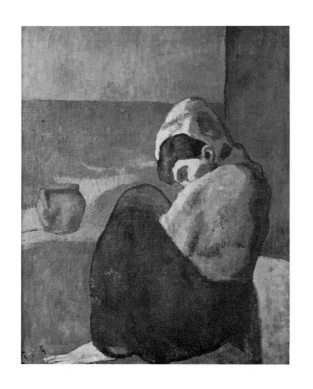

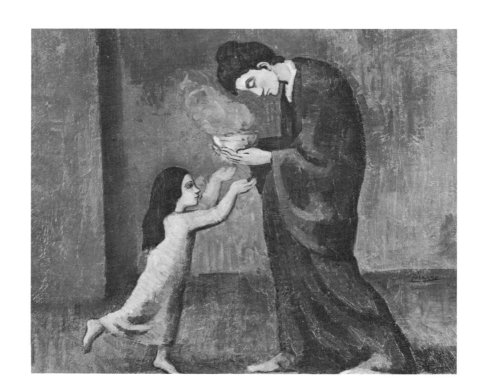

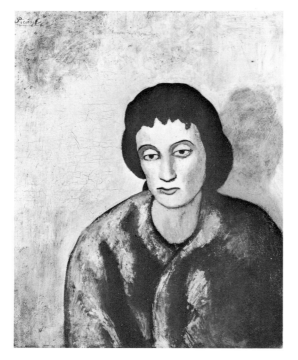

no, he repeated, you have to know something to paint a picture, you have to, you have to.

Well he was in Paris and all painting had an influence upon him and his literary friends were a great stimulation to him. I do not mean that by all this he was less Spanish. But certainly for a short time he was more French. Above all, and this is quite curious, the painting of Toulouse Lautrec greatly interested him, was it once more because Lautrec too had a literary side.

The thing that I want to insist upon is that Picasso's gift is completely the gift of a painter and a draughtsman, he is a man who always has need of emptying himself, of completely emptying himself, it is necessary that he should be greatly stimulated so that he could be active enough to empty himself completely.

This was always the way he lived his life.

After this first definite French influence, he became once more completely Spanish. Very soon the Spanish temperament was again very real inside in him. He went back again to Spain in 1902 and the painting known as his blue period was the result of that return.

The sadness of Spain and the monotony of the Spanish coloring, after the time spent in Paris, struck him forcibly upon his return there. Because one must never forget that Spain is not like other southern countries, it is not colorful, all the colors in Spain are white black silver or gold; there is no red or green, not at all. Spain in this sense is not at all southern, it is oriental, women there wear black more often than colors, the earth is dry and gold in color, the sky is blue almost black, the star-light nights are black too or a very dark blue and the air is very light, so that every one and everything is black. All the same I like Spain. Everything that was Spanish impressed

Top left: SEATED WOMAN WITH HOOD, *Barcelona, 1902, Oil. Staatsgalerie, Stuttgart.*

Bottom left: WOMAN WITH BANGS, *Barcelona, 1902, Oil. The Baltimore Museum of Art, Cone Collection.*

Right: MOTHER AND CHILD *(La Soupe), Barcelona, 1902, Oil. Collection Mr. and Mrs. Harold Crang, Toronto.*

11

Top: THE BEGGARS MEAL, *Barcelona, 1903–1904, Watercolor. Private Collection, Paris.*

Bottom: FAMILY AT SUPPER, *Barcelona, 1903, Ink and watercolor. Albright-Knox Art Gallery, Buffalo, New York. Room of Contemporary Art Fund.*

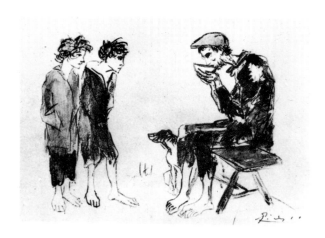

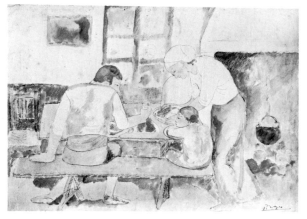

itself upon Picasso when he returned there after his second absence and the result is what is known as his blue period. The French influence which had made his first or Toulouse Lautrec one was over and he had returned to his real character, his Spanish character.

Then again in 1904 he was once again in Paris.

He lived in Montmartre, in the rue Ravignan, its name has been changed now, but the last time I was there it still had its old charm, the little square was just as it was the first time I saw it, a carpenter was working in a corner, the children were there, the houses were all about the same as they had been, the old atelier building where all of them had lived was still standing, perhaps since then, for it is two or three years that I was there last, perhaps now they have commenced to tear it all down and build another building. It is normal to build new buildings but all the same one does not like anything to change, and the rue Ravignan of that time was really something, it was the rue Ravignan and it was there that many things that were important in the history of twentieth century art happened.

Anyway Picasso had once more returned to Paris and it was around 1904 and he brought back with him the pictures of the blue period, also a little landscape of this period which he had painted in Barcelona. Once more back in Paris he commenced again to be a little French, that is he was again seduced by France, there was his intimacy with Guillaume Apollinaire and Max Jacob and André Salmon and they were constantly seeing each other, and this once again relieved his Spanish solemnity and so once more, needing to completely empty himself of everything he had, he emptied himself of the blue period, of the renewal of the Spanish spirit and that over he commenced painting what is now called the rose or harlequin period.

Painters have always liked the circus, even now when the circus is replaced by the cinema and night clubs, they like to remember the clowns and acrobats of the circus.

At this time they all met at least once a week at the Cirque Medrano and there they felt very flattered because they could be intimate with the clowns, the jugglers, the horses and their riders. Picasso little by little was more and more French and this started the rose or harlequin period. Then he emptied himself of this, the gentle poetry of France and the circus, he emptied himself of them in the same way that he had emptied himself of the blue period and I first knew him at the end of this harlequin period.

The first picture we had of his is, if you like, rose or harlequin, it is The Young Girl with a Basket of Flowers; it was painted at the great moment of the harlequin period, full of grace and delicacy and charm. After that little by little his drawing hardened, his line became firmer, his color more vigorous, naturally he was no longer a boy he was a man, and then in 1905 he painted my portrait.

Why did he wish to have a model before him just at this time, this I really do not know, but everything pushed him to it, he was completely emptied of the inspiration of the harlequin period, being Spanish commenced again to be active inside in him and I being an American, and in a kind of a way America and Spain have something in common, perhaps for all these reasons he wished me to pose for him. We met at Sagot's, the picture dealer, from whom we had bought The Young Girl with a Basket of Flowers. I posed for him all that winter, eighty times and in the end he painted out the head, he told me that he could not look at me any more and then he left once more for Spain. It was the first time since the blue period and immediately upon his return from Spain he painted in the head without having

LA BELLE QUI PASSE, *1904, Ink. Collection Mr. and Mrs. Daniel Saidenberg, New York.*

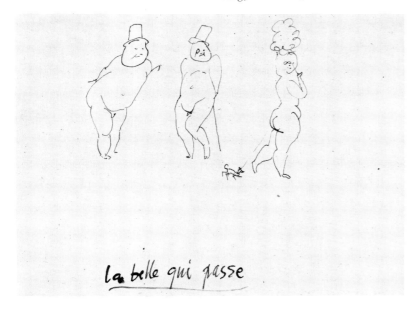

13

seen me again and he gave me the picture and I was and I still am satisfied with my portrait; for me, it is I, and it is the only reproduction of me which is always I, for me.

A funny story.

One day a rich collector came to my house and he looked at the portrait and he wanted to know how much I had paid for it. Nothing I said to him, nothing he cried out, nothing I answered, naturally he gave it to me. Some days after I told this to Picasso, he smiled, he doesn't understand, he said, that at that time the difference between a sale and a gift was negligible.

Once again Picasso in 1909 was in Spain and he brought back with him some landscapes which were, certainly were, the beginning of cubism. These three landscapes were extraordinarily realistic and all the same the beginning of cubism. Picasso had by chance taken some photographs of the village that he had painted and it always amused me when every one protested against the fantasy of the pictures to make them look at the photographs which made them see that the pictures were almost exactly like the photographs. Oscar Wilde used to say that nature did nothing but copy art and really there is some truth in this and certainly the Spanish villages were as cubistic as these paintings.

So Picasso was once more baptised Spanish.

Then commenced the long period which Max Jacob has called the Heroic Age of Cubism, and it was an heroic age. All ages are heroic, that is to say there are heroes in all ages who do things because they cannot do otherwise and neither they nor the others understand how and why these things happen. One does not ever understand, before they are completely created, what is happening and one does not at all understand what one has done until the moment when it is all done. Picasso said once that he who created a thing is forced to make it ugly. In the

14

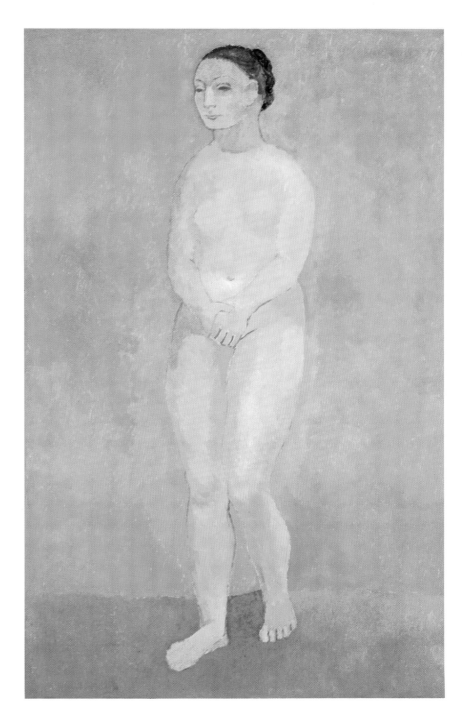

GRAND ROSE NUDE, *Gosol, Summer 1906, Oil. Collection Mr. and Mrs. William S. Paley, New York.*

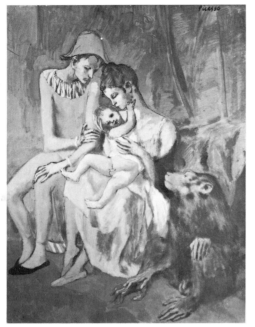

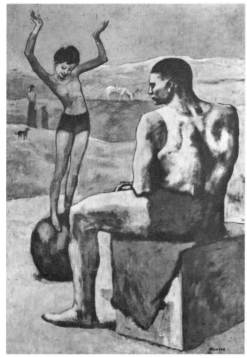

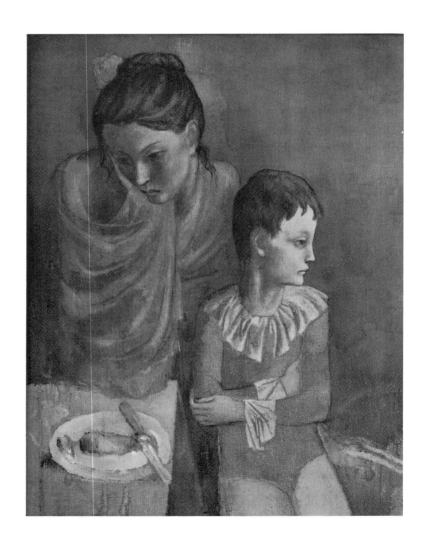

effort to create the intensity and the struggle to create this intensity, the result always produces a certain ugliness, those who follow can make of this thing a beautiful thing because they know what they are doing, the thing having already been invented, but the inventor because he does not know what he is going to invent inevitably the thing he makes must have its ugliness.

At this period 1908–1909, Picasso had almost never exhibited his pictures, his followers showed theirs but he did not. He said that when one went to an exhibition and looked at the pictures of the other painters one knows that they are bad, there is no excuse for it they are simply bad, but one's own pictures, one knows the reasons why they are bad and so they are not hopelessly bad. At this time he liked to say and later too he used to repeat it, there are so few people who understand and later when every one admires you there are still the same few who understand, just as few as before.

So then Picasso came back from Spain, 1909, with his landscapes that were the beginning of cubism. To really create cubism he had still a long way to go but a beginning had been made.

One can say that cubism has a triple foundation. First. The nineteenth century having exhausted its need of having a model, because the truth that the things seen with the eyes are the only real things, had lost its significance.

People really do not change from one generation to another, as far back as we know history people are about the same as they were, they have had the same needs, the same desires, the same virtues and the same qualities, the same defects, indeed nothing changes from one generation to another except the things seen and the things seen make that generation, that is to say nothing changes in people from one generation to an-

Top left: THE ACROBAT'S FAMILY WITH A MONKEY, *Paris, 1905, Gouache, pastel, and India ink. The Gothenburg Art Gallery, Gothenburg, Sweden.*

Bottom left: YOUNG ACROBAT ON A BALL, *Paris, 1905, Oil. The Pushkin Museum, Moscow.*

Right: MOTHER AND CHILD *(Saltim-banques), Paris, 1905, Gouache. Staatsgalerie, Stuttgart.*

17

Gertrude Stein in the Luxembourg Gardens, Paris, circa 1903. "America is my country and Paris is my home town and it is as it has come to be."

other except the way of seeing and being seen, the streets change, the way of being driven in the streets change, the buildings change, the comforts in the houses change, but the people from one generation to another do not change. The creator in the arts is like all the rest of the people living, he is sensitive to the changes in the way of living and his art is inevitably influenced by the way each generation is living, the way each generation is being educated and the way they move about, all this creates the composition of that generation.

This summer I was reading a book written by one of the monks of the Abbey of Hautecombe about one of the abbots of Hautecombe and in it he writes of the founding of the abbey and he tells that the first site was on a height near a very frequented road. Then I asked all my French friends what was in the fifteenth century a very frequented road, did it mean that people passed once a day or once a week. More than that, they answered me. So then the composition of that epoch depended upon the way the roads were frequented, the composition of each epoch depends upon the way the frequented roads are frequented, people remain the same, the way their roads are frequented is what changes from one century to another and it is that that makes the composition that is before the eyes of every one of that generation and it is that that makes the composition that a creator creates.

I very well remember at the beginning of the war being with Picasso on the boulevard Raspail when the first camouflaged truck passed. It was at night, we had heard of camouflage but we had not yet seen it and Picasso amazed looked at it and then cried out, yes it is we who made it, that is cubism.

Really the composition of this war, 1914–1918, was not the composition of all previous wars, the composition was not a composition in which there was one man in the centre

18

surrounded by a lot of other men but a composition that had neither a beginning nor an end, a composition of which one corner was as important as another corner, in fact the composition of cubism.

At present another composition is commencing, each generation has its composition, people do not change from one generation to another generation but the composition that surrounds them changes.

Now we have Picasso returning to Paris after the blue period of Spain, 1904, was past, after the rose period of France, 1905, was past, after the negro period, 1907, was past, with the beginning of his cubism, 1908, in his hand. The time had come.

I have said that there were three reasons for the making of this cubism.

First. The composition, because the way of living had changed, the composition of living had extended and each thing was as important as any other thing. Secondly, the faith in what the eyes were seeing, that is to say the belief in the reality of science, commenced to diminish. To be sure science had discovered many things, she would continue to discover things, but the principle which was the basis of all this was completely understood, the joy of discovery was almost over.

Thirdly, the framing of life, the need that a picture exist in its frame, remain in its frame was over. A picture remaining in its frame was a thing that always had existed and now pictures commenced to want to leave their frames and this also created the necessity for cubism.

The time had come and the man. Quite naturally it was a Spaniard who had felt it and done it. The Spaniards are perhaps the only Europeans who really never have the feeling that things seen are real, that the truths of science make

Gertrude Stein near Fiesole, 1908.

for progress. Spaniards did not mistrust science they only never have recognised the existence of progress. While other Europeans were still in the nineteenth century, Spain because of its lack of organisation and America by its excess of organisation were the natural founders of the twentieth century.

Cubism was commencing. Returning from Spain Picasso went back to the rue Ravignan but it was almost the end of the rue Ravignan, he commenced to move from one studio to another in the same building and when cubism was really well established, that is the moment of the pictures called Ma Jolie, 1910, he had left the rue Ravignan and a short time after he left Montmartre, 1912, and he never after returned to it.

After his return from Spain with his first cubist landscapes in his hand, 1909, a long struggle commenced.

Cubism began with landscapes but inevitably he then at once tried to use the idea he had in expressing people. Picasso's first cubist pictures were landscapes, he then did still lifes but Spaniard that he is, he always knew that people were the only interesting thing to him. Landscapes and still lifes, the seduction of flowers and of landscapes, of still lifes were inevitably more seductive to Frenchmen than to Spaniards, Juan Gris always made still lifes but to him a still life was not a seduction it was a religion, but the ecstasy of things seen, only seen; never touches the Spanish soul.

The head the face the human body these are all that exist for Picasso. I remember once we were walking and we saw a learned man sitting on a bench, before the war a learned man could be sitting on a bench, and Picasso said, look at that face, it is as old as the world, all faces are as old as the world.

And so Picasso commenced his long struggle to express heads faces and bodies of men and of women in the

20

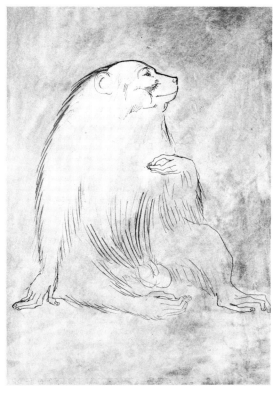

MONKEY, *Paris, 1905, Watercolor and ink. The Baltimore Museum of Art, Cone Collection.*

Top: COMPOSITION BLEU AU POUSSIN, *Paris, 1905, Wood engraving. Collection Mr. and Mrs. John Hay Whitney, New York.*

Bottom: COMPOSITION ROUGE AU VAUTOR, *Paris, 1905, Wood engraving. Private Collection, New York.*

composition which is his composition. The beginning of this struggle was hard and his struggle is still a hard struggle, the souls of people do not interest him, that is to say for him the reality of life is in the head, the face and the body and this is for him so important, so persistent, so complete that it is not at all necessary to think of any other thing and the soul is another thing.

The struggle then had commenced.

Most people are more predetermined as to what is the human form and the human face than they are as to what are flowers, landscapes, still lifes. Not everybody. I remember one of the first exhibitions of Van Gogh, there was an American there and she said to her friend, I find these portraits of people quite interesting for I don't know what people are like but I don't at all like these flower pictures because I know very well what flowers are like.

Most people are not like that. I do not mean to say that they know people better than they know other things but they have stronger convictions about what people are than what other things are.

Picasso at this period often used to say that Spaniards cannot recognise people from their photographs. So the photographers made two photographs, a man with a beard and a man smooth shaven and when the men left home to do their military service they sent one of these two types of photographs to their family and the family always found it very resembling.

It is strange about everything, it is strange about pictures, a picture may seem extraordinarily strange to you and after some time not only it does not seem strange but it is impossible to find what there was in it that was strange.

A child sees the face of its mother, it sees it in a com-

21

LETTER TO LEO STEIN, *Pen and Ink.*
Collection Mr. and Mrs. Perry
T. Rathbone, Cambridge, Massa-
chusetts.

pletely different way than other people see it, I am not speaking of the spirit of the mother, but of the features and the whole face, the child sees it from very near, it is a large face for the eyes of a small one, it is certain the child for a little while only sees a part of the face of its mother, it knows one feature and not another, one side and not the other, and in his way Picasso knows faces as a child knows them and the head and the body. He was then commencing to try to express this consciousness and the struggle was appalling because, with the exception of some African sculpture, no one had ever tried to express things seen not as one knows them but as they are when one sees them without remembering having looked at them.

Really most of the time one sees only a feature of a person with whom one is, the other features are covered by a hat, by the light, by clothes for sport and everybody is accustomed to complete the whole entirely from their knowledge, but Picasso when he saw an eye, the other one did not exist for him and only the one he saw did exist for him and as a painter, and particularly as a Spanish painter, he was right, one sees what one sees, the rest is a reconstruction from memory and painters have nothing to do with reconstruction, nothing to do with memory, they concern themselves only with visible things and so the cubism of Picasso was an effort to make a picture of these visible things and the result was disconcerting for him and for the others, but what else could he do, a creator can only do one thing, he can only continue, that is all he can do.

The beginning of this struggle to express the things, only the really visible things, was discouraging, even for his most intimate friends, even for Guillaume Apollinaire.

At this time people had commenced to be quite interested in the painting of Picasso, not an enormous number of

STUDY FOR "THE ACTOR" WITH TWO
PROFILES OF FERNANDE, *Paris, Winter
1904–1905, Pencil. Private Collection,
New York.*

people but even so quite a few, and then Roger Fry, an Englishman, was very impressed by my portrait and he had it reproduced in The Burlington Magazine, the portrait by Picasso next to a portrait by Raphael, and he too was very disconcerted. Picasso said to me once with a good deal of bitterness, they say I can draw better than Raphael and probably they are right, perhaps I do draw better, but if I can draw as well as Raphael I have at least the right to choose my way and they should recognise it, that right, but no, they say no.

I was alone at this time in understanding him, perhaps because I was expressing the same thing in literature, perhaps because I was an American and, as I say, Spaniards and Americans have a kind of understanding of things which is the same.

Later Derain and Braque followed him and helped him, but at this time the struggle remained a struggle for Picasso and not for them.

We are now still in the history of the beginning of that struggle.

Picasso commenced as I have said, at the end of the harlequin or rose period to harden his lines his construction and his painting and then he once more went to Spain, he stayed there all summer and when he came back he commenced some things which were harder and more absolute and this led him to do the picture Les Demoiselles d'Avignon. He left again for Spain and when he returned he brought back with him those three landscapes which were the real beginning of cubism.

It is true certainly in the water colors of Cézanne that there was a tendency to cut the sky not into cubes but into arbitrary divisions, there too had been the pointilism of Seurat and his followers, but that had nothing to do with cubism, because all these other painters were preoccupied with their

23

technique which was to express more and more what they were seeing, the seduction of things seen. Well then, from Courbet to Seurat they saw the things themselves, one may say from Courbet to Van Gogh and to Matisse they saw nature as it is, if you like, that is to say as everybody sees it.

One day they asked Matisse if, when he ate a tomato, he saw it as he painted it. No said Matisse, when I eat it I see it as everybody sees it and it is true from Courbet to Matisse, the painters saw nature as every one sees it and their preoccupation was to express that vision, to do it with more or less tenderness, sentiment, serenity, penetration but to express it as all the world saw it.

I am always struck with the landscapes of Courbet, because he did not have to change the color to give the vision of nature as every one sees it. But Picasso was not like that, when he ate a tomato the tomato was not everybody's tomato, not at all and his effort was not to express in his way the things seen as every one sees them, but to express the thing as he was seeing it. Van Gogh at even his most fantastic moment, even when he cut off his ear, was convinced that an ear is an ear as every one could see it, the need for that ear might be something else but the ear was the same ear everybody could see.

But with Picasso, Spaniard that he is, it was entirely different. Well, Don Quixote was a Spaniard, he did not imagine things, he saw things, and it was not a dream, it was not lunacy, he really saw them.

Well Picasso is a Spaniard.

I was very much struck at this period, when cubism was a little more developed, with the way Picasso could put objects together and make a photograph of them. I have kept one of them, and by the force of his vision it was not neces-

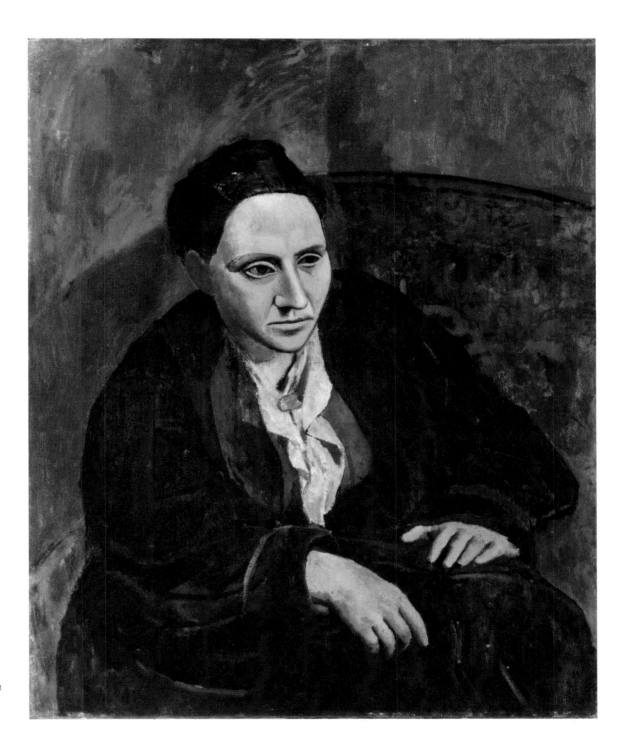

PORTRAIT OF GERTRUDE STEIN, *Paris,*
Autumn 1906, Oil. The Metropolitan
Museum of Art, New York. Bequest
of Gertrude Stein, 1946.

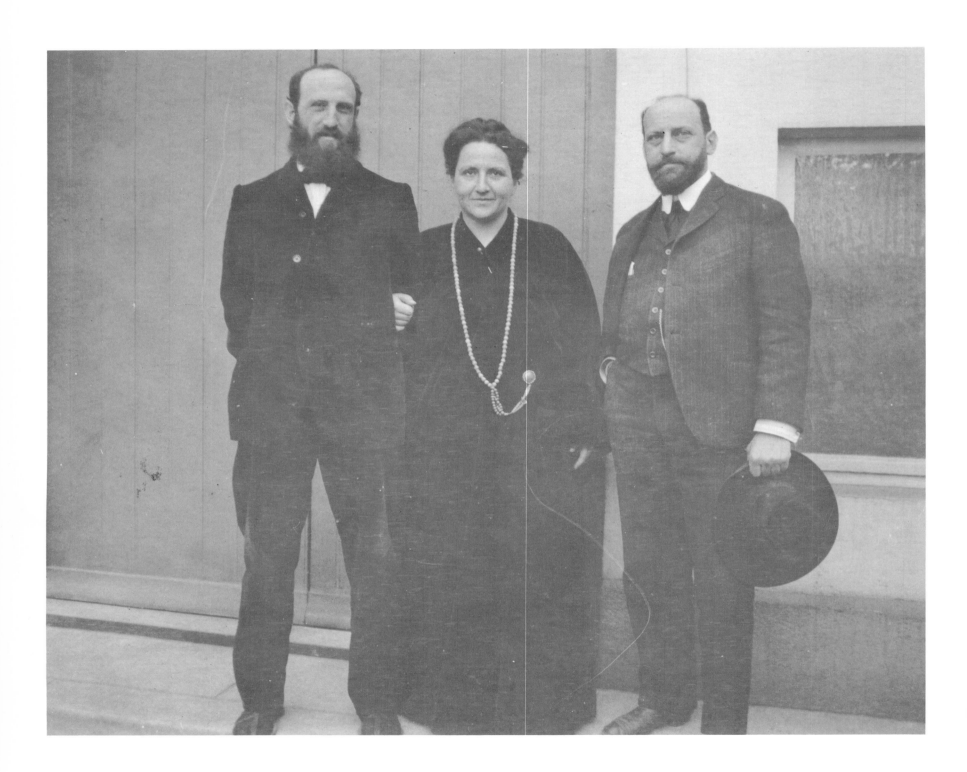

sary that he paint the picture. To have brought the objects together already changed them to other things, not to another picture but to something else, to things as Picasso saw them.

But as I say, Spaniards and Americans are not like Europeans, they are not like Orientals, they have something in common, that is they do not need religion or mysticism not to believe in reality as all the world knows it, not even when they see it. In fact reality for them is not real and that is why there are sky-scrapers and American literature and Spanish painting and literature.

So Picasso commenced and little by little there came the picture Les Demoiselles d'Avignon and when there was that it was too awful. I remember, Tschoukine who had so much admired the painting of Picasso was at my house and he said almost in tears, what a loss for French art.

In the beginning when Picasso wished to express heads and bodies not like every one could see them, which was the problem of other painters, but as he saw them, as one can see when one has not the habit of knowing what one is looking at, inevitably when he commenced he had the tendency to paint them as a mass as sculptors do or in profile as children do.

African art commenced in 1907 to play a part in the definition of what Picasso was creating, but in the creations of Picasso really African art like the other influences which at one time or another diverted Picasso from the way of painting which was his, African art and his French cubist comrades, were rather things that consoled Picasso's vision than aided it, African art, French cubism and later Italian and Russian were like Sancho Panza was with Don Quixote, they wished to lead Picasso away from his real vision which was his real Spanish vision.

Leo, Gertrude, and Michael Stein in front of the studio at 27, rue de Fleurus, circa 1907.

The things that Picasso could see were the things which had their own reality, reality not of things seen but of things that exist. It is difficult to exist alone and not being able to remain alone with things, Picasso first took as a crutch African art and later other things.

Let us go back to the beginning of cubism.

He commenced the long struggle not to express what he could see but not to express the things he did not see, that is to say the things everybody is certain of seeing, but which they do not really see. As I have already said, in looking at a friend one only sees one feature of her face or another, in fact Picasso was not at all simple and he analysed his vision, he did not wish to paint the things that he himself did not see, the other painters satisfied themselves with the appearance, and always the appearance, which was not at all what they could see but what they knew was there.

There is a difference.

Now the dates of this beginning.

Picasso was born in Malaga, October 25th, 1881. His parents settled definitely in Barcelona in 1895 and the young Picasso came for the first time in 1900 to Paris where he stayed six months.

The first influence in Paris was Toulouse Lautrec, at this time and later, until his return to Paris in 1901, the influence of this first contact with Paris was quite strong, he returned there in the spring of 1901, but not to stay for long and he returned to Barcelona once more. The direct contact with Paris the second time destroyed the influences of Paris, he returned again to Barcelona and remained there until 1904 when he really became an inhabitant of Paris.

During this period, 1901 to 1904, he painted the blue

28

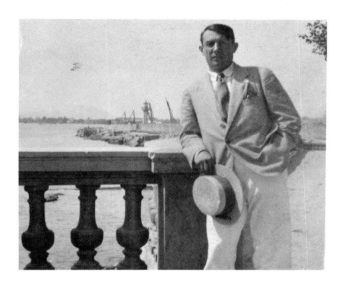

Picasso in St. Raphael, August 1919.

Top: PORTRAIT OF GUILLAUME APOLLINAIRE, *Paris, 1905, India Ink. Collection Lionel Prejger, Paris.*

Bottom: THE TWO GIANTS, *Paris, 1905, India Ink. Collection Jan Krugier, Geneva.*

pictures, the hardness and the reality which are not the reality seen, which is Spanish, made him paint these pictures which are the basis of all that he did afterwards.

In 1904 he came back to France, he forgot all the Spanish sadness and Spanish reality, he let himself go, living in the gaiety of things seen, the gaiety of French sentimentality. He lived in the poetry of his friends, Apollinaire, Max Jacob and Salmon, as Juan Gris always used to say, France seduces me and she still seduces me, I think this is so, France for Spaniards is rather a seduction than an influence.

So the harlequin or rose period was a period of enormous production, the gaiety of France induced an unheard of fecundity. It is extraordinary the number and size of the canvases he painted during this short period, 1904–1906.

Later one day when Picasso and I were discussing the dates of his pictures and I was saying to him that all that could not have been painted during one year Picasso answered, you forget we were young and we did a great deal in a year.

Really it is difficult to believe that the harlequin period only lasted from 1904 to 1906, but it is true, there is no denying it, his production upon his first definite contact with France was enormous. This was the rose period.

The rose period ended with my portrait, the quality of drawing had changed and his pictures had already commenced to be less light, less joyous. After all Spain is Spain and it is not France and the twentieth century in France needed a Spaniard to express its life and Picasso was destined for this. Really and truly.

When I say that the rose period is light and happy everything is relative, even the subjects which were happy ones were a little sad, the families of the harlequins were wretched

29

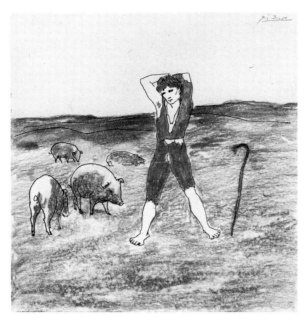

THE SWINEHERD, *1906, Ink with added pencil. Collection Mr. and Mrs. Daniel Saidenberg, New York.*

Top left: BUST OF A LITTLE BOY, *Paris, 1905, Gouache. The Baltimore Museum of Art, Cone Collection.*

Bottom left: NUDE WITH HAIR PULLED BACK, *Paris, 1905, Gouache. Present location unknown.*

Right: SEATED NUDE, *Paris, 1905, Oil. Museé National d'Art Moderne, Paris.*

families but from Picasso's point of view it was a light happy joyous period and a period when he contented himself with seeing things as anybody did. And then in 1906 this period was over.

In 1906 Picasso worked on my portrait during the whole winter, he commenced to paint figures in colors that were almost monotone, still a little rose but mostly an earth color, the lines of the bodies harder, with a great deal of force there was the beginning of his own vision. It was like the blue period, but much more felt and less colored and less sentimental. His art commenced to be much purer.

So he renewed his vision which was of things seen as he saw them.

One must never forget that the reality of the twentieth century is not the reality of the nineteenth century, not at all and Picasso was the only one in painting who felt it, the only one. More and more the struggle to express it intensified. Matisse and all the others saw the twentieth century with their eyes, but they saw the reality of the nineteenth century, Picasso was the only one in painting who saw the twentieth century with his eyes and saw its reality, and consequently his struggle was terrifying, terrifying for himself and for the others, because he had nothing to help him, the past did not help him, nor the present, he had to do it all alone and, as in spite of much strength he is often very weak, he consoled himself and allowed himself to be almost seduced by other things which led him more or less astray.

Upon his return from a short trip to Spain, he had spent the summer at Gosol, he returned and became acquainted with Matisse through whom he came to know African sculpture.

After all one must never forget that African sculpture is not naive, not at all, it is an art that is very very conven-

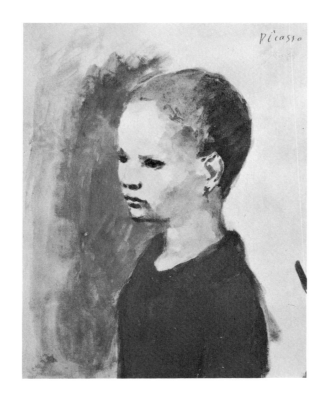

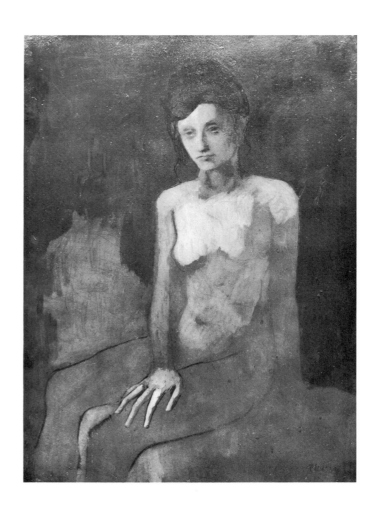

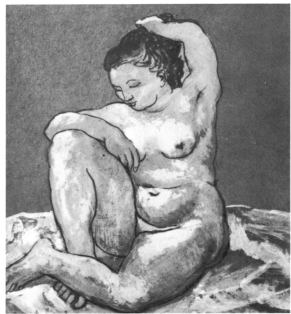

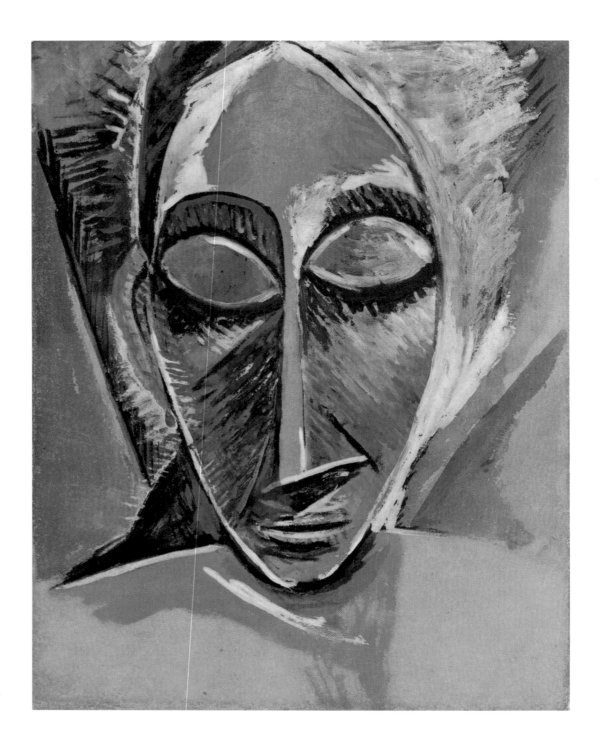

HEAD, *Paris, 1907, Oil and tempera.*
Private Collection, New York.

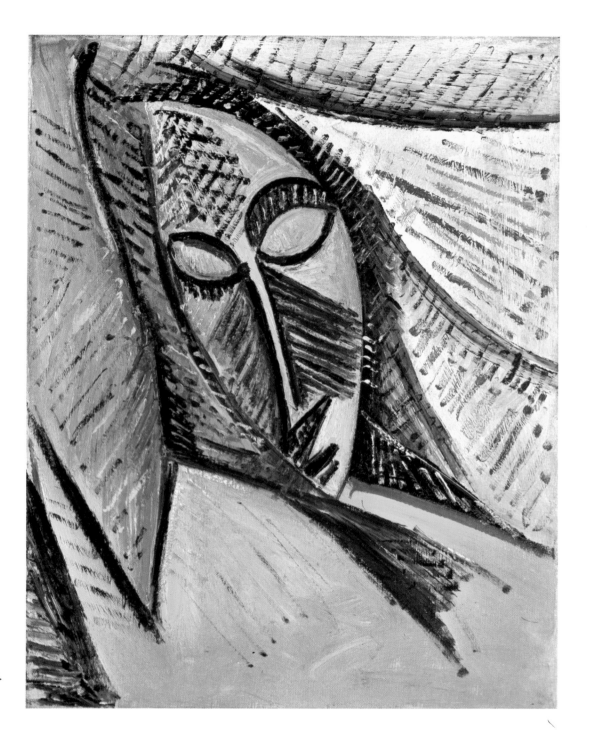

HEAD OF A WOMAN, *Paris, 1906, Oil.*
Collection Mr. and Mrs. John Hay
Whitney, New York.

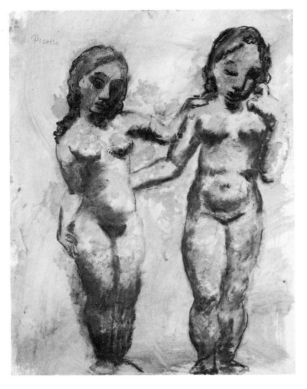
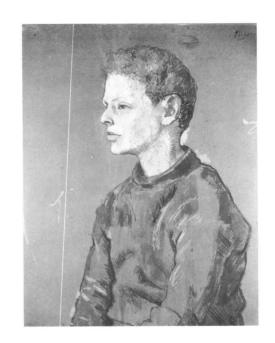
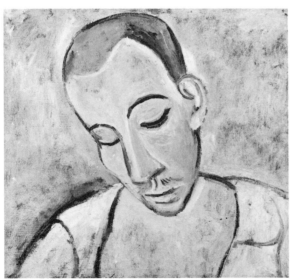
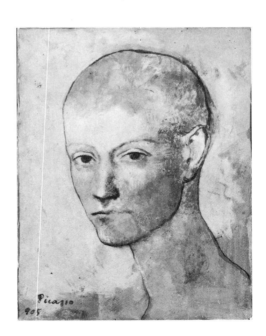

tional, based upon tradition and its tradition is a tradition derived from Arab culture. The Arabs created both civilisation and culture for the negroes and therefore African art which was naive and exotic for Matisse was for Picasso, a Spaniard, a thing that was natural, direct and civilised.

So then it was natural that this reinforced his vision and helped him to realise it and the result was the studies which brought him to create the picture of Les Demoiselles d'Avignon.

Again and again he did not recommence but he continued after an interruption. This is his life.

It was about this period that his contact with Derain and Braque commenced and little by little pure cubism came to exist.

First there was the effort, still more difficult than with still lifes and landscapes; to create human beings in cubes, exhausted, Picasso emptied himself during 1907 and calmed himself by doing sculpture. Sculpture always has the bother that one can go all around it and the material of which it is made gives an impression of form before the sculptor has worked on it.

I myself prefer painting.

Picasso having a prodigious effort to create painting by his understanding of African sculpture was seduced a short time after 1908 by his interest in the sculptural form rather than by the vision in African sculpture, but even so in the end it was an intermediate step toward cubism.

Cubism is a part of the daily life in Spain, it is in Spanish architecture. The architecture of other countries always follows the line of the landscape, it is true of Italian architecture and of French architecture, but Spanish architecture always cuts the lines of the landscape, and it is that that is the basis of cubism, the work of man is not in harmony with the landscape, it opposes it and it is just that that is the basis of cubism

Top left: TWO NUDES, Paris, Autumn 1906, Gouache, charcoal, and water-color. The Baltimore Museum of Art, Cone Collection.

Bottom left: HEAD OF A SAILOR, Paris, 1905–1906, Oil. Collection Mr. and Mrs. David Rockefeller, New York.

Top right: PORTRAIT OF ALLAN STEIN, Paris, 1906, Gouache. The Baltimore Museum of Art, Cone Collection.

Bottom right: HEAD OF A YOUNG MAN, Paris, 1905–1906, Gouache. The Cleveland Museum of Art, Bequest of Leonard C. Hanna, Jr.

35

The Steins were continually rearranging the walls of 27, rue de Fleurus as they acquired new works. These photographs of the studio were taken in 1908.
Top: Works by Manguin, Gauguin, Picasso, Toulouse-Lautrec, Matisse, Cézanne, Renoir, and Delacroix.

Bottom: Works by Picasso, Vallotton, Maurice Denis, Cézanne, and Matisse.

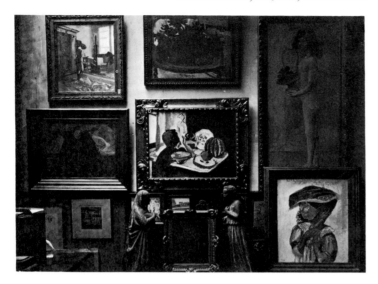

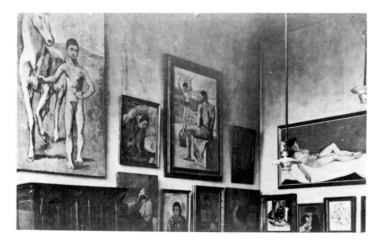

and that is what Spanish cubism is. And that was the reason for putting real objects in the pictures, the real newspaper, the real pipe. Little by little, after these cubist painters had used real objects, they wanted to see if by the force of the intensity with which they painted some of these objects, a pipe, a newspaper, in a picture, they could not replace the real by the painted objects which would by their realism require the rest of the picture to oppose itself to them.

Nature and man are opposed in Spain, they agree in France and this is the difference between French cubism and Spanish cubism and it is a fundamental difference.

So then Spanish cubism is a necessity, of course it is.

So now it is 1908 and once more Picasso is in Spain and he returned with the landscapes of 1909 which were the beginning of classic and classified cubism.

These three landscapes express exactly what I wish to make clear, that is to say the opposition between nature and man in Spain. The round is opposed to the cube, a small number of houses gives the impression of a great quantity of houses in order to dominate the landscape, the landscape and the houses do not agree, the round is opposed to the cube, the movement of the earth is against the movement of the houses, in fact the houses have no movement because the earth has its movement, of course the houses should have none.

I have here before me a picture of a young French painter, he too with few houses creates his village, but here the houses move with the landscape, with the river, here they all agree together, it is not at all Spanish.

Spaniards know that there is no agreement, neither the landscape with the houses, neither the round with the cube, neither the great number with the small number, it was

36

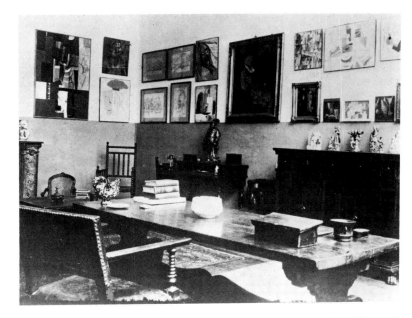

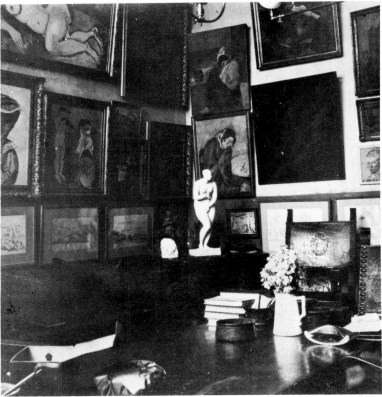

Top left: 27, rue de Fleurus, 1913.
Both the Cubist Man with a Guitar
and the Student with a Pipe *had been*
added to the collection. It was at this
desk, facing the Cézanne Portrait of
Madame Cézanne, *that Stein, a few*
years earlier, had written Three Lives.

Bottom left: By 1912, the year of this
photograph, 27, rue de Fleurus had
already acquired its reputation as the
first museum of modern art.

Right: 27, due de Fleurus, Summer
1969. Although it has been painted
and repaired, the apartment remains
as it was during Gertrude Stein's
residency.

natural that a Spaniard should express this in the painting of the twentieth century, the century where nothing is in agreement, neither the round with the cube, neither the landscape with the houses, neither the large quantity with the small quantity. America and Spain have this thing in common, that is why Spain discovered America and America Spain, in fact it is for this reason that both of them have found their moment in the twentieth century.

So Picasso returned from Spain after a summer spent in Barcelona and in Horta de Ebro and he was once again in the rue Ravignan, but it was the beginning of the end of the rue Ravignan, actually he did not leave the rue Ravignan until 1910, but the return in 1909 was really the end of the rue Ravignan which had given him all that it would give him, that was over and now began the happy era of cubism. There was still a great deal of effort, the continual effort of Picasso to express the human form, that is to say the face, the head, the human body in the composition which he had then reached, the features seen separately existed separately and at the same time it all was a picture, the struggle to express that at this time was happy rather than sad. The cubists found a picture dealer, the young Kahnweiler, coming from London, full of enthusiasm, wishing to realise his dream of becoming a picture dealer, and hesitating a little here and there and definitely becoming interested in Picasso. In 1907 and in 1908, in 1909 and in 1910, he made contracts with the cubists, one after the other, French and Spanish and he devoted himself to their interests. The life of the cubists became very gay, the gaiety of France once again seduced Picasso, every one was gay, there were more and more cubists, the joke was to speak of some one as the youngest of the cubists, cubism was sufficiently accepted now that one could speak of the

MAISONS SUR LA COLLINE, *Horta de Ebro, Summer 1909, Oil. Private Collection, New York.*

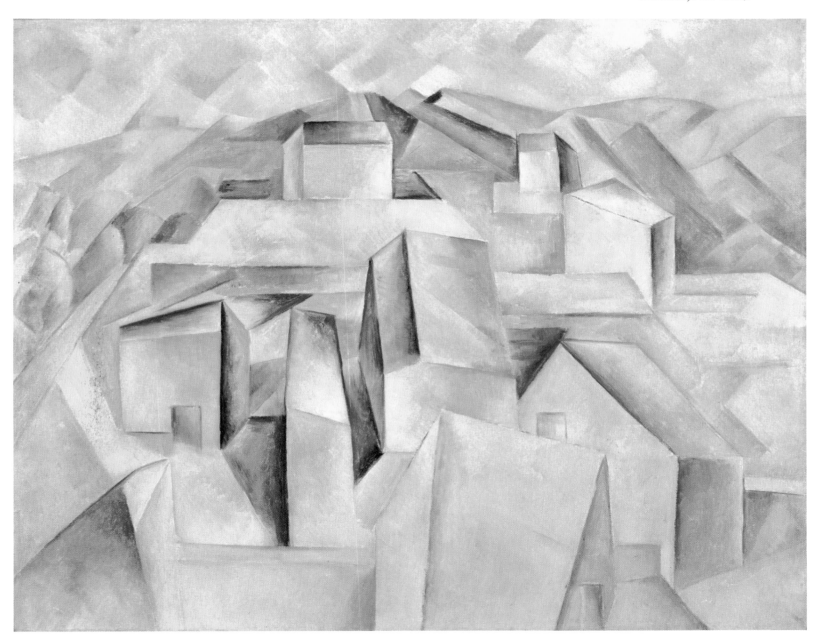

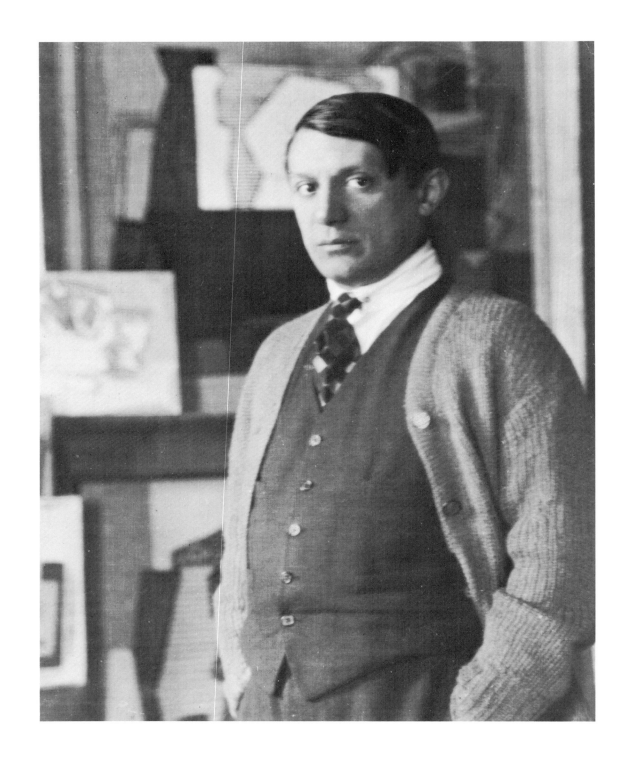

youngest of the cubists, after all he did exist and every one was gay. Picasso worked enormously as he always worked, but every one was gay.

This gaiety lasted until he left Montmartre in 1912. After that not one of them was ever so gay again. Their gaiety then was a real gaiety.

He left the rue Ravignan, 1911, to move to the boulevard de Clichy and he left the boulevard de Clichy and Montmartre to settle in Montparnasse in 1912. Life between 1910 and 1912 was very gay, it was the period of the Ma Jolie pictures, it was the period of all those still lifes, the tables with their grey color, with their infinite variety of greys, they amused themselves in all sorts of ways, they still collected African sculpture but its influence was not any longer very marked, they collected musical instruments, objects, pipes, tables with fringes, glasses, nails, and at this time Picasso commenced to amuse himself with making pictures out of zinc, tin, pasted paper. He did not do any sculpture, but he made pictures with all these things. There is only one left of those made of paper and that he gave me one day and I had it framed inside a box. He liked paper, in fact everything at this time pleased him and everything was going on very livelily and with an enormous gaiety.

Everything continued but there were interruptions.

Leaving Montmartre was an interruption, Picasso left there in 1912, and the gaiety was over, everything continued, everything always continues but Picasso was never again so gay, the gay moment of cubism was over.

He left Montmartre for Montparnasse, first the boulevard Raspail, then the rue Schoelcher and finally Montrouge.

During all this time he did not return to Spain but during the summer he was at Ceret or at Sorgues, the begin-

Picasso in his studio, 1934. Courtesy Yale University Library, Gertrude Stein Collection.

41

13, rue Ravignan (now place Emile Goudeau) where Picasso painted the Portrait of Gertude Stein. *This building was also the home of André Salmon, Max Jacob, Juan Gris, and, earlier, of Paul Verlaine. Photograph by Carl Van Vechten.*

Top: Fernande Oliver was among those who occupied 13, rue Ravignan, nicknamed the bateau lavoir *after the laundry barges on the nearby Seine. She first met Picasso in 1904, one year after he had arrived in Paris. Her almond eyes were the inspiration for the face of the* Grand Rose Nude. *Courtesy Yale University Library, Gertrude Stein Collection.*

Bottom: Marcelle Humbert, whom Picasso affectionately called Eva, inspired the Ma Jolie *period. This photograph was taken at Avignon in 1914. Courtesy Yale University Library, Gertrude Stein Collection.*

ning of life in Montparnasse was less gay, he worked enormously as he always does. It was at the rue Schoelcher that he commenced to paint with Ripolin paints, he commenced to use a kind of wall paper as a background and a small picture painted in the middle, he commenced to use pasted paper more and more in painting his pictures. Later he used to say quite often, paper lasts quite as well as paint and after all if it all ages together, why not, and he said further, after all, later, no one will see the picture, they will see the legend of the picture, the legend that the picture has created, then it makes no difference if the picture lasts or does not last. Later they will restore it, a picture lives by its legend, not by anything else, pasted paper is just as good for creating a legend as anything else. He was indifferent as to what might happen to his pictures even though what might happen to them affected him profoundly, well that is the way one is, why not, one is like that.

Very much later, when he had had a great deal of success, he said one day, you know, your family, everybody, if you are a genius and unsuccessful, everybody treats you as if you were a genius, but when you come to be successful, when you commence to earn money, when you are really successful, then your family and everybody no longer treats you like a genius, they treat you like a man who has become successful.

So success had begun, not a great success, but enough success.

At this time, he was still at the rue Schoelcher, and Picasso for the first time used the Russian alphabet in his pictures. It is to be found in a few of the pictures of this period, of course this was long before his contact with the Russian ballet. So life went on. His pictures became more and more brilliant in color, more and more carefully worked and perfected and then there was war, it was 1914.

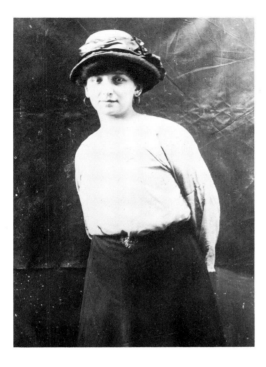

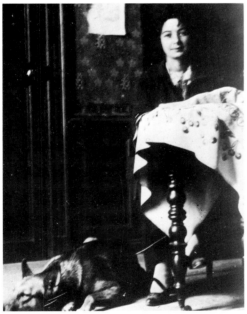

At this period his pictures were very brilliant in color, he painted musical instruments and musical signs, but the cubic forms were continually being replaced by surfaces and lines, the lines were more important than anything else, they lived by and in themselves. He painted his pictures not by means of his objects but by the lines, at this time this tendency became more and more pronounced.

Then there was the war and all his friends left to go to the war.

Picasso was still at the rue Schoelcher, Braque and Derain were mobilised and at the front, but Apollinaire had not yet gone, he was not French so he was not called but shortly after he did volunteer. Everybody had gone. Picasso was alone. Apollinaire's leaving perhaps affected him the most, Apollinaire who wrote him all his feelings in learning to become a warrior, that was then 1914 and now it was all war.

Later he moved from the rue Schoelcher to Montrouge and it was during this moving that the objects made of paper and zinc and tin were lost and broken. Later at Montrouge he was robbed, the burglars took his linen. It made me think of the days when all of them were unknown and when Picasso said that it would be marvellous if a real thief came and stole his pictures or his drawings. Friends, to be sure, took some of them, stole them if you like from time to time, pilfered if you like, but a real professional burglar, a burglar by profession, when Picasso was not completely unknown, came and preferred to take the linen.

So little by little time passed. Picasso commenced to know Erik Satie and Jean Cocteau and the result was Parade, that was the end of this period, the period of real cubism.

Jean Cocteau left for Rome with Picasso, 1917, to prepare Parade. It was the first time that I saw Cocteau, they came together to say good-bye, Picasso was very gay, not so

43

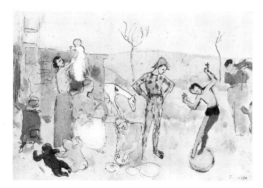

Top: YOUNG MAN ON A SUNDAY WALK, *Paris, 1905, Pen and Ink. Collection Mr. and Mrs. John D. Schiff.*

Bottom: CIRCUS FAMILY, *Paris, 1905, Watercolor and India ink. The Baltimore Museum of Art, Cone Collection.*

gay as in the days of the great cubist gaiety but gay enough, he and Cocteau were gay, Picasso was pleased to be leaving, he had never seen Italy. He never had enjoyed travelling, he always went where others already were, Picasso never had the pleasure of initiative. As he used to say of himself, he has a weak character and he allowed others to make decisions, that is the way it is, it was enough that he should do his work, decisions are never important, why make them.

So cubism was to be put on the stage. That was really the beginning of the general recognition of Picasso's work, when a work is put on the stage of course every one has to look at it and in a sense if it is put on the stage every one is forced to look and since they are forced to look at it, of course, they must accept it, there is nothing else to do. In the spring of 1917 Picasso was in Italy with Diaghilew and with Cocteau and he made the stage settings and the costumes for Parade which is completely cubist. It had a great success, it was produced and accepted, of course, from the moment it was put on the stage, of course, it was accepted.

So the great war continued but it was nearing its end, and the war of cubism, it too was commencing to end, no war is ever ended, of course not, it only has the appearance of stopping. So Picasso's struggle continued but for the moment it appeared to have been won by himself for himself, and by him for the world.

It is an extraordinary thing but it is true, wars are only a means of publicising the things already accomplished, a change, a complete change, has come about, people no longer think as they were thinking but no one knows it, no one recognises it, no one really knows it except the creators. The others are too busy with the business of life, they cannot feel what has happened, but the creator, the real creator, does nothing, he is not

44

Top: STUDIES FOR "TWO NUDES," *Paris, Autumn 1906, Conté crayon. The Museum of Fine Arts, Boston. Arthur Tracy Cabot Fund.*

Bottom: BOY ON HORSEBACK *(and other sketches), Paris, 1906, Pen. Private Collection, New York.*

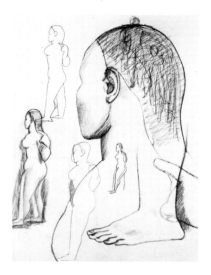

concerned with the activity of existing, and as he is not active, that is to say as he is not concerned with the activity of existence he is sensitive enough to understand how people are thinking, he is not interested in knowing how they were thinking, his sensitive feeling is concerned in understanding how people live as they are living. The spirit of everybody is changed, of a whole people is changed, but mostly nobody knows it and a war forces them to recognise it, because during a war the appearance of everything changes very much quicker, but really the entire change has been accomplished and the war is only something which forces everybody to recognise it. The French revolution was over when war forced everybody to recognise it, the American revolution was accomplished before the war, the war is only a publicity agent which makes every one know what has happened, yes, it is that.

So then the public recognises a creator who has seen the change which has been accomplished before a war and which has been expressed by the war, and by the war the world is forced to recognise the entire change in everything, they are forced to look at the creator who, before any one, knew it and expressed it. A creator is not in advance of his generation but he is the first of his contemporaries to be conscious of what is happening to his generation.

A creator who creates, who is not an academician, who is not some one who studies in a school where the rules are already known, and of course being known they no longer exist, a creator then who creates is necessarily of his generation. His generation lives in its contemporary way, but they only live in it. In art, in literature, in the theatre, in short in everything that does not contribute to their immediate comfort they live in the preceding generation. It is very simple, to-day in the streets of

45

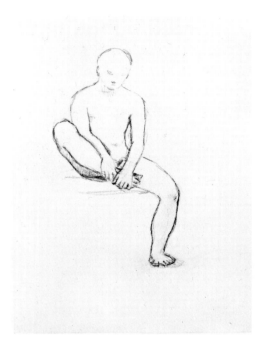

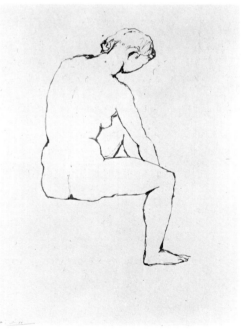

Paris, horses, even tramcars can no longer exist but horses and tramcars are only suppressed only when they cause too many complications, they are suppressed but sixty years too late. Lord Grey said when the war broke out that the generals thought of a war of the nineteenth century even when the instruments of war were of the twentieth century and only when the war was at its height did the generals understand that it was a war of the twentieth century, and not a war of the nineteenth century. That is what the academic spirit is, it is not contemporary, of course not, and so it can not be creative because the only thing that is creative in a creator is the contemporary thing. Of course.

As I was saying, in the daily living it is another thing. A friend built a modern house and he suggested that Picasso too should have one built. But, said Picasso, of course not, I want an old house. Imagine, he said, if Michael Angelo would have been pleased if some one had given him a fine piece of Renaissance furniture, not at all. He would have been pleased if he had been given a beautiful Greek intaglio, of course.

So that is the way it is, a creator is so completely contemporary that he has the appearance of being ahead of his generation and to calm himself in his daily living he wishes to live with the things in the daily life of the past, he does not wish to live as contemporary as the contemporaries who do not poignantly feel being contemporary. This sounds complicated but it is very simple.

So when the contemporaries were forced by the war to recognise cubism, cubism as it had been created by Picasso who saw a reality that was not the vision of the nineteenth century, which was not a thing seen but felt, which was a thing that was not based upon nature but opposed to nature like the houses in Spain are opposed to the landscape, like the round is

46

Top: STUDY FOR "TWO YOUTHS,"
*Gosol, Summer 1906, Crayon. Private
Collection, New York.*

Bottom: SEATED NUDE, *1906, Pen.
Collection Mr. and Mrs. Richard K.
Weil, St. Louis, Missouri.*

STUDY FOR "WOMAN WITH LOAVES,"
*Gosol, Summer 1906, Pencil. Present
location unknown.*

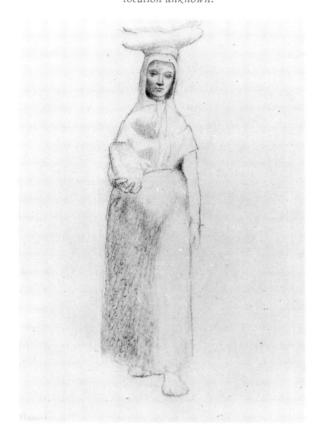

opposed to cubes. Every one was forced by the war which made them understand that things had changed to other things and that they had not stayed the same things, they were forced then to accept Picasso. Picasso returned from Italy and freed by Parade, which he had just created, he became a realistic painter, he even made many portraits from models, portraits which were purely realistic. It is evident that really nothing changes, but at the same time everything changes, and Italy and Parade and the termination of the war gave to Picasso in a kind of a way another harlequin period, a realistic period, not sad, less young, if you like, but a period of calm, he was satisfied to see things as everybody saw them, not completely as everybody does but completely enough. Period of 1917 to 1920.

Picasso was always possessed by the necessity of emptying himself, of emptying himself completely, of always emptying himself, he is so full of it that all his existence is the repetition of a complete emptying, he must empty himself, he can never empty himself of being Spanish, but he can empty himself of what he has created. So every one says that he changes, but really it is not that, he empties himself and the moment he has completed emptying himself he must recommence emptying himself, he fills himself up again so quickly.

Twice in his life he almost emptied himself of being Spanish, the first time during his first real contact with Paris when there came the harlequin or rose period, 1904–1906, the second time was his contact with the theatre, that was the realistic period which lasted from 1918 to 1921. During this period he painted some very beautiful portraits, some paintings and some drawings of harlequins and many other pictures. This adult rose period lasted almost three years.

But of course the rose period could not persist in him.

47

He emptied himself of the rose period and inevitably it changed to something else, this time it changed to the period of large women and later to one of classic subjects, women with draperies, perhaps this was the commencement of the end of this adult rose period.

There certainly have been two rose periods in the life of Picasso. During the second rose period there was almost no real cubism but there was painting which was writing which had to do with the Spanish character, that is to say the Saracen character and this commenced to develop very much.

I will explain.

In the Orient calligraphy and the art of painting and sculpture have always been very nearly related, they resemble each other, they help each other, they complete each other. Saracen architecture was decorated with letters, with words in Sanskrit letters, in China the letters were something in themselves. But in Europe the art of calligraphy was always a minor art, decorated by painting, decorated by lines, but the art of writing and the decoration by writing and the decoration around writing are always a minor rat. But for Picasso, a Spaniard, the art of writing, that is to say calligraphy, is an art. After all the Spaniards and the Russians are the only Europeans who are really a little Oriental, and this shows in the art of Picasso, not as anything exotic, but as something quite profound. It is completely assimilated, of course he is a Spaniard, and a Spaniard can assimilate the Orient without imitating it, he can know Arab things without being seduced, he can repeat African things without being deceived.

The only things that really seduce the Spaniards are Latin things, French things, Italian things, for them the Latin is exotic and seductive, it is the things the Latins make which for the Spaniards are charming. As Juan Gris always said, the

48

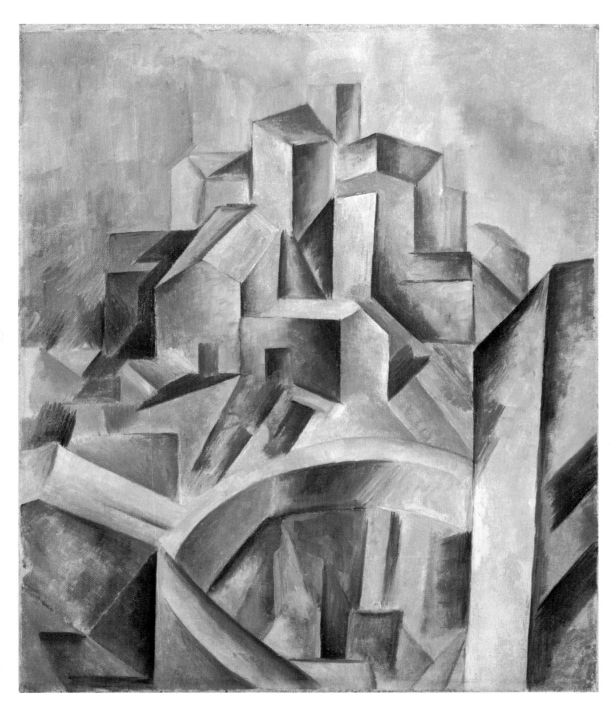

THE RESERVOIR, HORTA DE EBRO,
*Summer 1909, Oil. Collection Mr. and
Mrs. David Rockefeller, New York.*

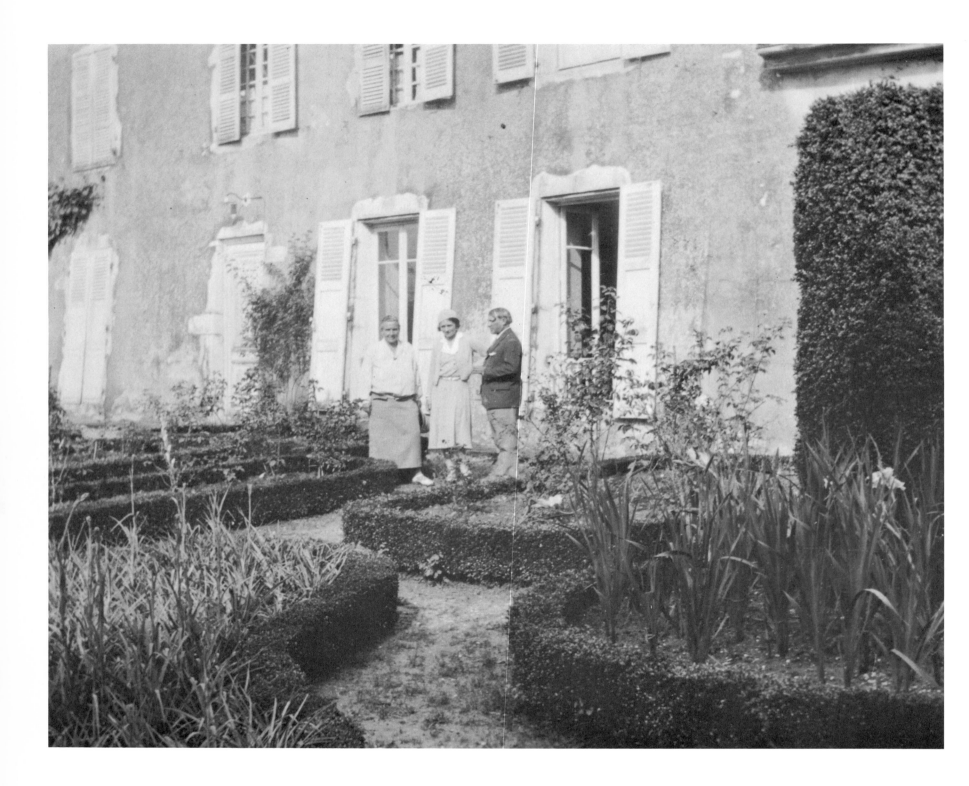

school of Fontainebleau was completely a seducation, it was of course completely Latin, Italy in France.

So then the Italian seduction resulted for Picasso after his first visit to Rome in his second rose period which commenced in 1918 with the portrait of his wife and lasted until the portrait of his son in harlequin costume in 1927, and all this began with portraits, then the large women, to end with classic subjects. It was once more Latin seduction this time by means of Italy. But above all it was always and always Spain and it was Spain which impelled him even during this naturalistic period to express himself by calligraphy in his pictures.

The first thing I saw that showed this calligraphic quality in Picasso were several wood-cuts which he had made during the harlequin period, that first rose period of 1904. There were two birds made in a single stroke and colored with only one color. Besides these two small things I do not remember any other things of his which were really calligraphic until his last period of pure cubism, that is to say from 1912 to 1917.

During this period the cubes were no longer important, the cubes were lost. After all one must know more than one sees and one does not see a cube in its entirety. In 1914 there were less cubes in cubism, each time that Picasso commenced again he recommenced the struggle to express in a picture the things seen without association but simply as things seen and it is only the things seen that are knowledge for Picasso. Related things are things remembered and for a creator, certainly for a Spanish creator, certainly for a Spanish creator of the twentieth century, remembered things are not things seen, therefore they are not things known. And so then always and always Picasso commenced his attempt to express not things felt, not things remembered, not established in relations, but things

Gertrude Stein, Madame Olga Picasso, and Pablo Picasso on the terrace at Bilignin. Summer 1930.

51

Gertrude Stein, Alice B. Toklas, and the Picassos on the terrace at Bilignin, Summer 1930. Courtesy Yale University Library, Gertrude Stein Collection.

which are there, really everything a human being can know at each moment of his existence and not an assembling of all his experiences. So that during all this last period of pure cubism, 1914–1917, he tried to recommence his work, at the same time he became complete master of his metier. It was the interval between 1914 and 1917 when his mastery of his technique became so complete that it reached perfection, there was no longer any hesitation, now when he knew what to do he could do what he wanted to do, no technical problem stopped him. But after all, this problem remained, how to express not the things seen in association but the things really seen, not things interpreted, but things really known at the time of knowing them. All his life this had been his problem but the problem had become more difficult than ever, now that he was completely master of his technique he no longer had any real distraction, he could no longer have the distraction of learning, his instrument was perfected.

At this period, from 1913 to 1917, his pictures have the beauty of complete mastery. Picasso nearly did all that he wanted to do, he put into his pictures nearly nothing that should not have been there, there were no cubes, there were simply things, he succeeded in only putting into them what he really knew and all that ended with the voyage to Italy and the preparation of Parade.

After Italy and Parade he had his second naturalistic period of which anybody could recognise the beauty and his technique which was now perfected permitted him to create this beauty with less effort, this beauty existed in itself.

These pictures have the serenity of perfect beauty but they have not the beauty of realisation. The beauty of realisation is a beauty that always takes more time to show itself as beauty than pure beauty does. The beauty of realisation during its creation is not beauty, it is only beauty when the things that

Top: Picasso at Bilignin. Summer 1930. Courtesy Yale University Library, Gertrude Stein Collection.

Bottom: Paulot Picasso with the family dogs. Bilignin, Summer 1930.

follow it are created in its image. It is then that it is known as beauty on account of its quality of fecundity, it is the most beautiful beauty, more beautiful than the beauty of serenity. Well.

After Italy and Parade Picasso married and in 1918 he left Montrouge for the rue de la Boëtie; he stayed there until 1937 and during this time, 1910 to 1937, there were many things created, many things happened to the painting of Picasso.

But let us return to calligraphy and its importance in Picasso's art.

It was natural that the cubism of 1913 to 1917 revealed the art of calligraphy to him, the importance of calligraphy seen as Orientals see it and not as Europeans see it. The contact with Russia, first through a Russian G. Apostrophe as they all called him, and later with the Russian ballet, stimulated his feeling for calligraphy which is always there in a Spaniard always since Spaniards have had for such a long time Saracen art always with them.

And also one must never forget that Spain is the only country in Europe whose landscape is not European, not at all, therefore it is natural that although Spaniards are Europeans even so they are not Europeans.

So in all this period of 1913 to 1917 one sees that he took great pleasure in decorating his pictures, always with a rather calligraphic tendency than a sculptural one, and during the naturalist period, which followed Parade and the voyage to Italy, the consolation offered to the side of him that was Spanish was calligraphy. I remember very well in 1923 he did two women completely in this spirit, a very little picture but all the reality of calligraphy was in it, everything that he could not put into his realistic pictures was there in the two calligraphic

53

women and they had an extraordinary vitality.

Calligraphy, as I understand it in him had perhaps its most intense moment in the *décor* of Mercure. That was written, so simply written, no painting, pure calligraphy. A little before that he had made a series of drawings, also purely calligraphic, the lines were extraordinarily lines, there were also stars that were stars which moved, they existed, they were really cubism, that is to say a thing that existed in itself without the aid of association or emotion.

During all this time the realistic period was commencing to approach its end, first there had been portraits which ended with harlequins, for once Picasso had almost wished to look at models. The naturalistic painting changed to the large women, at first women on the shore or in the water, with a great deal of movement, and little by little the large women became very sculpturesque. In this way Picasso emptied himself of Italy. That is his way.

During the year 1923 his pleasure in drawing was enormous, he almost repeated the fecundity and the happiness of his first rose period, everything was in rose. That ended in 1923. It was at this time that the classic period commenced, it was the end of Italy, it still showed in his drawings but in his painting he had completely purged himself of Italy, really entirely.

Then came the period of the large still-lifes, 1927, and then for the first time in his life six months passed without his working. It was the very first time in his life.

It is necessary to think about this question of calligraphy, it must never be forgotten that the only way Picasso has of speaking, the only way Picasso has of writing is with drawings and paintings. In 1914 and from then on it never stopped, he had a certain way of writing his thoughts, that is to say

Left: SEATED NUDE WITH FOLDED ARMS, *1906, Pen. Collection Mr. and Mrs. Richard K. Weil, St. Louis, Missouri.*

Top right: HEAD OF A YOUNG MAN, *Paris, Autumn 1906, Oil. Collection Mr. André Meyer, New York.*

Bottom right: PORTRAIT OF LEO STEIN, *Paris, Spring 1906, Gouache. The Baltimore Museum of Art, Cone Collection.*

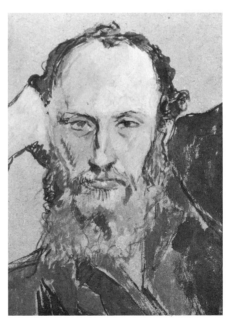

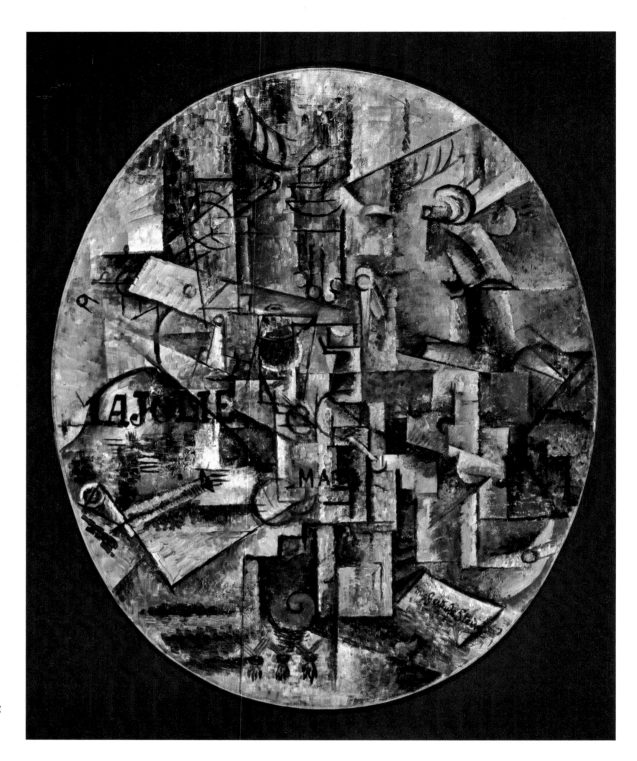

THE ARCHITECT'S TABLE, *Paris, Spring 1912, Oil. Collection Mr. and Mrs. William S. Paley, New York.*

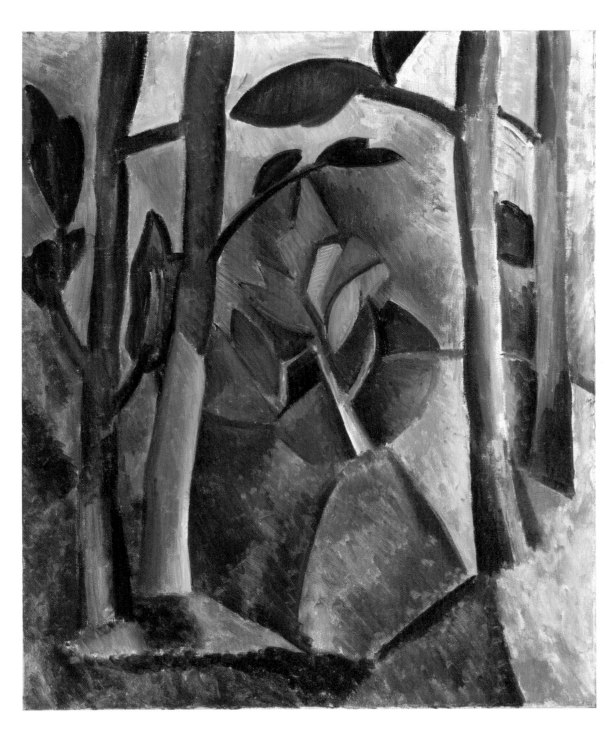

GREEN LANDSCAPE, *1908, Oil.Collection Mr. and Mrs. David Rockefeller, New York.*

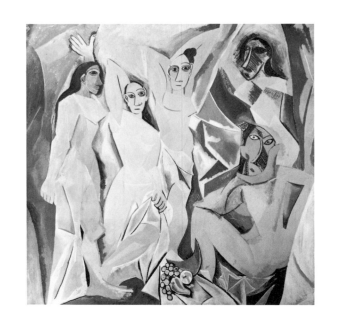

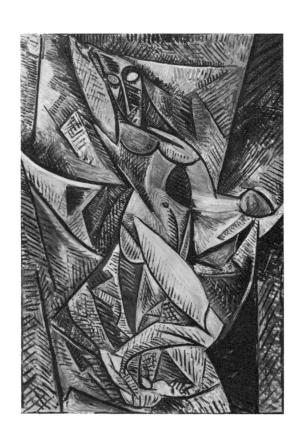

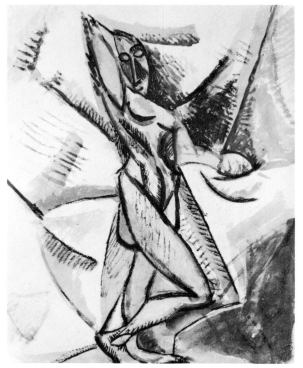

of seeing things in a way that he knew he was seeing them. And it was in this way that he commenced to write these thoughts with drawings and with painting. Oriental people, the people of America and the people of Spain have never, really never forgotten that it is not necessary to use letters in order to be able to write. Really one can write in another way and Picasso has understood, completely understood this way. To recapitulate. From 1914 to 1917 cubism changed to rather flat surfaces, it was no longer sculpture, it was writing and Picasso really expressed himself in this way because it was not possible, really not, to really write with sculpture, no, not.

So it was natural that at this period, 1913 to 1917, during which time he was almost always alone, he should recommence writing all he knew and he knew many things. As I have said, it was then he completely mastered the technique of painting. And this ended with Parade.

Now a great struggle commenced again. The influence of Italy, the influence of everybody's return from the war, the influence of a great deal of recognition and the influence of his joy at the birth of his son, precipitated him into a second rose period, a completely realistic period which lasted from 1919 to 1927. This was a rose period, it certainly was and in the same way as the first rose period it ended when Picasso commenced to strengthen and harden his lines and solidify the forms and the colors, in the same way that the first rose period changed with my portrait so this rose period changed about 1920 by painting enormous and very robust women. There was still a little the memory of Italy in its forms and draperies and this lasted until 1923 when he finished the large classical pictures. So the second rose period naturally ended in the same way as the first one had, that is to say by the triumph of Spain. It was

Top left: LES DEMOISELLES D'AVIGNON, *Spring 1907, Oil. The Museum of Modern Art. Acquired through the Lillie P. Bliss Bequest.*

Bottom left: NUDE WITH RAISED ARM, *Paris, 1907, Watercolor. The Baltimore Museum of Art, Cone Collection.*

Right: NUDE WITH DRAPERY, *Paris, Summer 1907, Oil. The Hermitage, Leningrad.*

Top: STANDING NUDE, HANDS CLASPED, *Gosol, Summer 1906, Conté crayon. Collection Mr. and Mrs. Leigh B. Block, Chicago.*

Bottom: HEAD OF FERNANDE, *Gosol, 1906, Charcoal. The Art Institute of Chicago, Gift of Herman Waldeck.*

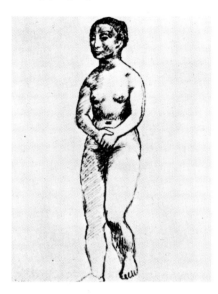

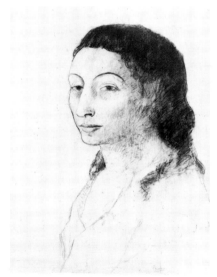

during all this period that he first painted about 1920 and 1921, very highly colored cubist pictures, very calligraphic and very colored and then more and more calligraphic and less colored. During all this time the color of this cubism was pure color, Ripolin paint, which he called the health of color.

Later I will tell something about Picasso's color which too, in itself, is a whole story.

To continue.

When the second rose period changed to the period of large women, around 1923, at the same time that calligraphy was in full activity, there commenced to be felt in the large pictures and it culminated in one of these large pictures La Danse, the fact that naturalism for Picasso was dead, that he was no longer seeing as all the world thought they saw.

And as the pure period of cubsim, that is to say the cubism of cubes, found its final explosion in Parade, so the pure writing of this period found its explosion in the ballet Mercure, in 1924 at the Soirées de Paris.

Then a curious story commenced, like the story of the African period and that of Les Demoiselles d'Avignon.

Picasso had purged himself of Italy in his second rose period and the large women and the classical subjects. He always had Spain inside him, he can not purge himself of that because it is he, it is himself, so then the writing which is the continuation of cubism, if it is not the same thing, was always continuing, but now there was another thing, it was Russia, and to rid himself of that was a terrible struggle. During this struggle things seen as everybody can see them nearly dominated him and to avoid this, avoid being conquered by this, for the first time in his life, and twice since, he stopped painting, he ceased speaking as he knew how to speak, writing as he knew how to write,

60

Top: Picasso, Madame Olga Picasso, Stein, and Madame Maratier relaxing on the terrace at Bilignin. Summer 1930.

Bottom: Gertrude Stein with the Picassos after Paulot Picasso's first communion, Paris, April 1943. Gertrude Stein and Alice B. Toklas were Paulot's godmothers. Photograph by Alice B. Toklas.

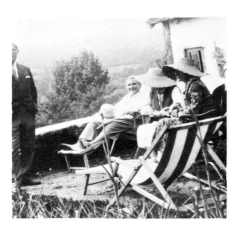

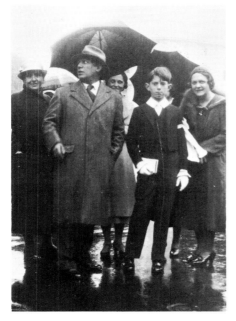

with drawings and with color.

We are now in 1924 and the production of Mercure.

At this time he began to do sculpture. I say that Italy was completely out of him but Russia was still in him. The art of Russia is essentially a peasant art, an art of speaking with sculpture. It requires a greater detachment to know how to speak with drawings and with color than to speak with sculpture in cubes or in round, and the African sculpture was cube and the Russian sculpture was round. There is also another very important difference, the size of the features and of the people in African sculpture is a real size, the size in Russian sculpture is an abnormal one so that one art is pure and the other fantastic, and Picasso a Spaniard is never fantastic, he is never pornographic but Russian art is both. Again a struggle.

The Spanish character is a mixture of Europe and the Orient, the Russian character is a mixture of the European and the Oriental but it is neither the same Europe nor the same Orient, but as it is the same mixture the struggle to become once more himself was harder than ever and from 1924 to 1935 this struggle lasted.

During this time his consolation was cubism, the harlequins big and little, and his struggle was in the large pictures where the forms in spite of being fantastic forms, were forms like everybody sees them, were, if you wish, pornographic forms, in a word forms like Russians can see them, but not forms like a Spaniard can see them.

As I have said and as I have repeated, the character, the vision of Picasso is like himself, it is Spanish and he does not see reality as all the world sees it, so that he alone amongst the painters did not have the problem of expressing the truths that all the world can see but the truths that he alone can see and

61

that is not the world the world recognises as the world.

As he has not the distraction of learning because he can create it the moment he knows what he sees, he having a sensitiveness and a tenderness and a weakness that makes him wish to share the things seen by everybody, he always in his life is tempted, as a saint can be tempted, to see things as he does not see them.

Again and again it has happened to him in his life and the strongest temptation was between 1925 and 1935.

The struggle was intense and sometimes almost mortal.

In 1937 he recommenced painting, he had not drawn nor painted for six months, as I have said several times the struggle was almost mortal, he must see what he saw and the reality for him had to be the reality seen not by everybody but by him and every one wished to lead him away from this, wished to force him to see what he did not see. It was like when they wanted to force Galileo to say that the earth did not turn. Yes it was that.

Just before the six months during which for the first time in his life he did not draw nor paint he had an enormous fecundity. Another way of finding himself again. An enormous production is as necessary as doing nothing in order to find one's self again, so then at first he had an enormous production and after it completely ceased during six months. During these six months the only thing he did was a picture made of a rag cut by a string, during the great moment of cubism he made such things, at that time it gave him great joy to do it but now it was a tragedy. This picture was beautiful, this picture was sad and it was the only one.

After this he commenced again but this time rather with sculpture than with painting, again and again he wanted to escape from those too well-known forms which were not the forms he saw and this was what induced him to make

62

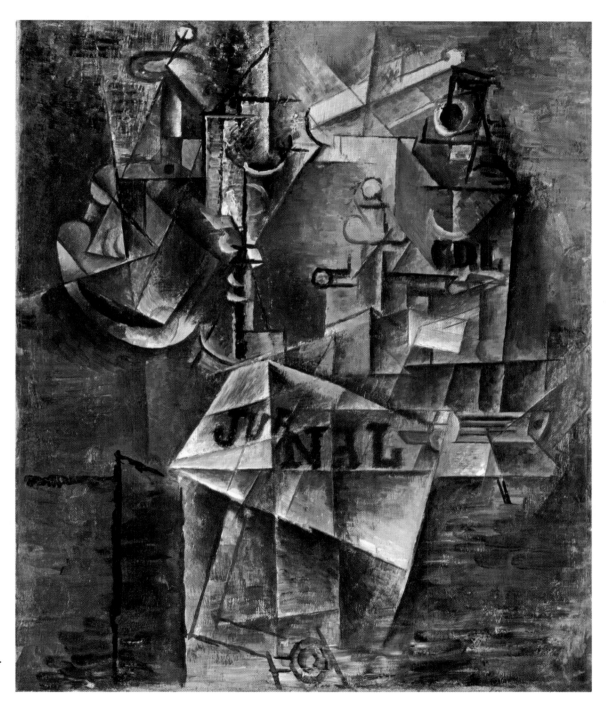

STILL LIFE *(Journal), Paris, Spring 1912, Oil and charcoal. Collection Mr. and Mrs. John Hay Whitney, New York.*

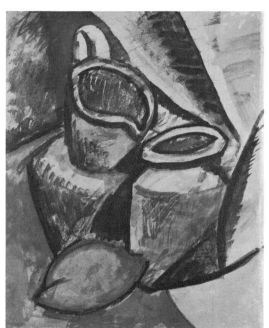

sculpture which at first was very very thin, as thin as a line, not thicker than that. That was perhaps why Greco made his figures as he did make them. Perhaps.

Almost at the same time he commenced to make enormous statues, all this to empty himself of those forms which were not forms he could see, I say that this struggle was formidable.

It was at this time, that is to say in 1933, that once more he ceased to paint but he continued to make drawings and during the summer of 1933 he made his only surrealist drawings. Surrealism could console him a little, but not really. The surrealists still see things as every one sees them, they complicate them in a different way but the vision is that of every one else, in short the complication is the complication of the twentieth century but the vision is that of the nineteenth century. Picasso only sees something else, another reality. Complications are always easy but another vision than that of all the world is very rare. That is why geniuses are rare, to complicate things in a new way that is easy, but to see the things in a new way that is really difficult, everything prevents one, habits, schools, daily life, reason, necessities of daily life, indolence, everything prevents one, in fact there are very few geniuses in the world.

Picasso saw something else, not another complication but another thing, he did not see things evolve as people saw them evolve in the nineteenth century, he saw things evolve as they did not evolve which was the twentieth century, in other words he was contemporary with the things and he saw these things, he did not see as all the others did, as all the world thought they saw, that is to say as they themselves saw them in the nineteenth century.

During this period there was another curious thing.

The color Picasso used was always important, so important that his periods were named after the color that he was

Top left: GLASSES AND FRUIT, *Paris, 1908, Oil. Private Collection, New York.*

Top right: STILL LIFE: GLASSES AND FRUIT, *Paris, Winter 1908, Oil. Private Collection, New York.*

Bottom: STILL LIFE WITH LEMON, *Paris, 1908, Oil. Collection Mr. and Mrs. David Rockefeller, New York.*

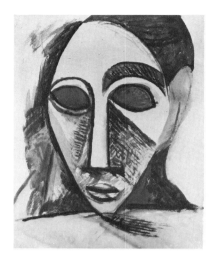

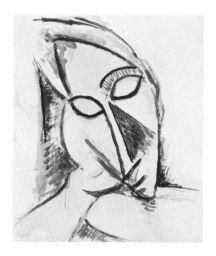

Top: HEAD IN BROWNS AND BLACK, *Paris, 1907, Oil. Private Collection, New York.*

Bottom: HEAD, *Paris, 1907, Oil. Private Collection, New York.*

using. To commence with the commencement.

The first influence of his first short visits to Paris, 1900, gave him the color of Toulouse Lautrec, the characteristic color of the painting of that period. That lasted a very short time and when he came back to Paris and returned to Spain, the colors he used were naturally Spanish, the color blue, and the pictures of this period were always blue. When he was in France again and when French gaiety made him gay he painted in rose and that is called the rose period. There was really some blue in this period but the blue had rather a rose character than a blue character, so then it was really a rose period, that was followed by the beginning of the struggle for cubism, the African period which had some rose but which turned first to beige, later to brown and red as in my portrait and after that there was an intermediary period, before real cubism and that was a rather green period. It is less known but it is very very beautiful, landscapes and large still-lifes, also some figures. After that there were pale landscapes which little by little were followed by grey still-lifes. It was during this grey period that Picasso really for the first time showed himself to be a great colorist. There is an infinite variety of grey in these pictures and by the vitality of painting the greys really become color. After that as Picasso had then really become a colorist his periods were not named after their colors.

He commenced, this was 1914, to study colors, the nature of colors, he became interested in making pure colors but the color quality which he found when he painted in grey was a little lost, later when his second naturalistic period was over he commenced again to be enormously interested in color, he played with colors to oppose the colors to the drawings, Spaniard that he was, it is natural that the colors should not help the drawing

66

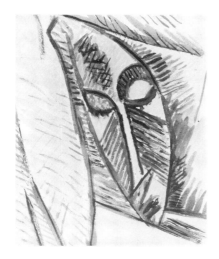

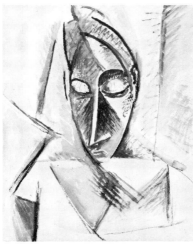

Top: STUDY FOR "NUDE WITH DRAPERY," *Paris, 1907, Oil. Collection Mr. and Mrs. Lionel Steinberg, Thermal, California.*

Bottom: HEAD, *Paris, 1907, Oil. Private Collection, New York.*

but should oppose themselves to it, and it was about 1923 that he interested himself enormously in this. It was also during the calligraphic period, 1923, and later that this opposition of drawing and of color was the most interesting.

Little by little when the struggle not to be subjugated by the vision which was not his vision was going on, the colors commenced to be rather the ordinary colors that other painters used, colors that go with the drawing and finally between 1927 and 1935 Picasso had a tendency to console himself with Matisse's conception of color, this was when he was most despairful that this commenced and this ended when he ceased to paint in 1935.

In fact, he ceased to paint during two years and he neither painted nor drew.

It is extraordinary that one ceases to do what one has done all one's life but that can happen.

It is always astonishing that Shakespeare never put his hand to his pen once he ceased to write and one knows other cases, things happen that destroy everything which forced the person to exist and the identity which was dependent upon the things that were done, does it still exist, yes or no.

Rather yes, a genius is a genius, even when he does not work.

So Picasso ceased to work.

It was very curious.

He commenced to write poems but this writing was never his writing. After all the egoism of a painter is not at all the egoism of a writer, there is nothing to say about it, it is not. No.

Two years of not working. In a way Picasso liked it, it was one responsibility the less, it is nice not having responsibilities, it is like the soldiers during a war, a war is terrible, they said, but during a war one has no responsibility, neither for death, nor for life. So these two years were like that for

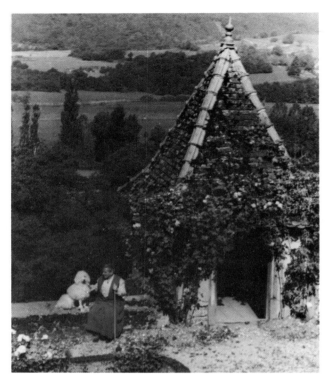

Gertrude Stein and Basket I on the terrace at Bilignin.

Picasso, he did not work, it was not for him to decide every moment what he saw, no, poetry for him was something to be made during rather bitter meditations, but agreeably enough, in a café.

This was his life for two years, of course he who could write, write so well with drawings and with colors, knew very well that to write with words as, for him, not to write at all. Of course he understood that but he did not wish to allow himself to be awakened, there are moments in life when one is neither dead nor alive and for two years Picasso was neither dead nor alive, it was not an agreeable period for him, but a period of rest, he, who all his life needed to empty himself and to empty himself, during two years he did not empty himself, that is to say not actively, actually he really emptied himself completely, emptied himself of many things and above all of being subjugated by a vision which was not his own vision.

As I have said Picasso knows, really knows the faces, the heads, the bodies of human beings, he knows them as they have existed since the existence of the human race, the soul of people does not interest him, why interest one's self in the souls of people when the face, the head, the body can tell everything, why use words when one can express everything by drawings and colors. During this last period, from 1927 to 1935, the souls of people commenced to dominate him and his vision, a vision which was as old as the creation of people, lost itself in interpretation. He who could see did not need interpretation and in these years, 1927 to 1935, for the first time, the interpretations destroyed his own vision so that he made forms not seen but conceived. All this is difficult to put into words but the distinction is plain and clear, it is why he stopped working. The only way to purge himself of a vision which was not his

68

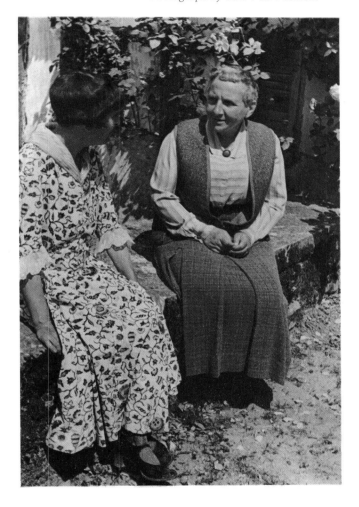

Gertrude Stein and Alice B. Toklas on the terrace at Bilignin, June 30, 1934. Photograph by Carl Van Vechten.

was to cease to express it, so that as it was impossible for him to do nothing he made poetry, but of course it was his way of falling asleep during the operation of detaching himself from the souls of things which were not his concern.

To see people as they have existed since they were created is not strange, it is direct, and Picasso's vision, his own vision, is a direct vision.

Finally war broken out in Spain.

First the revolution and then war.

It was not the events themselves that were happening in Spain which awoke Picasso but the fact that they were happening in Spain, he had lost Spain and here was Spain not lost, she existed, the existence of Spain awakened Picasso, he too existed, everything that had been imposd upon him no longer existed, he and Spain, both of them existed, of course they existed, they exist, they are alive, Picasso commenced to work, he commenced to speak as he has spoken all his life, speaking with drawings and color, speaking with writing, the writing of Picasso.

All his life he has only spoken like that, he has written like that, and he has been eloquent.

So in 1937 he commenced to be himself again.

He painted a large picture about Spain and it was written in a calligraphy continuously developed and which was the continuation of the great advancement made by him in 1922, now he was in complete effervescence, and at the same time he found his color. The color of the pictures he paints now in 1937 are bright colors, light colors but which have the qualities of the colors which until now only existed in his greys, the colors can oppose the drawing, they can go together with the drawing, they can do what they want, it is not that they can agree or not with the drawing that they are there, they are there

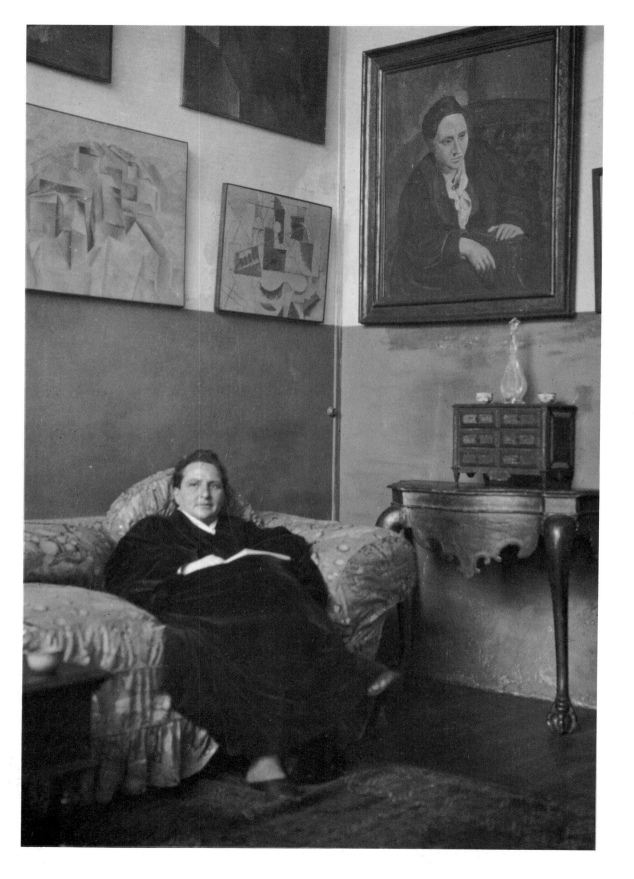

*Left: Gertrude Stein in 1919 beneath
Picasso's 1906 portrait of her.*

Right: Gertrude Stein in 1937.

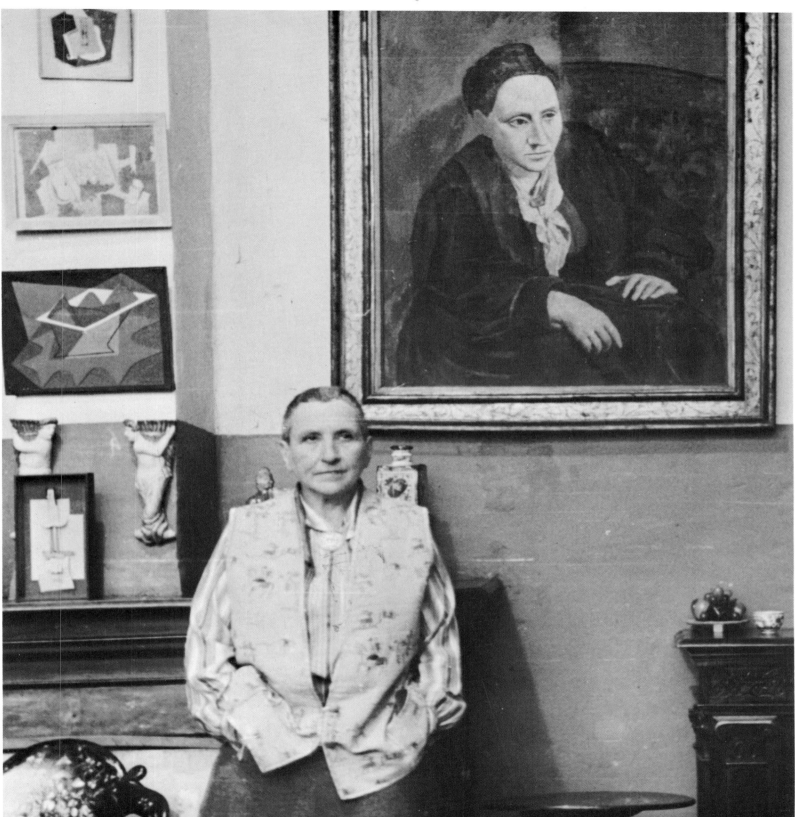

only to exist, certainly Picasso has now found his color, his real color in 1937.

Now this is the end of this story, not the end of his story, but the end of this story of his story.

Epilogue

To-day the pictures of Picasso have come back to me from the exhibition at the Petit Palais and once more they are on my walls, I can not say that during their absence I forgot their splendor but they are more splendid than that. The twentieth century is more splendid than the nineteenth century, certainly it is much more splendid. The twentieth century has much less reasonableness in its existence than the nineteenth century but reasonableness does not make for splendor. The seventeenth century had less reason in its existence than the sixteenth century and in consequence it has more splendor. So the twentieth century is that, it is a time when everything cracks, where everything is destroyed, everything isolates itself, it is a more splendid thing than a period where everything follows itself. So then the twentieth century is a splendid period, not a reasonable one in the scientific sense, but splendid. The phenomena of nature are more splendid than the daily events of nature, certainly, so then the twentieth century is splendid.

It was natural that it was a Spaniard who understood that a thing without progress is more splendid than a thing which progresses. The Spaniards who adore mounting a hill at full speed and coming down hill slowly, it is they who were made to create the painting of the twentieth century, and

STILL LIFE WITH PEARS, *Paris, Winter
1908, Oil. Collection Mr. and Mrs.
John Hay Whitney, New York.*

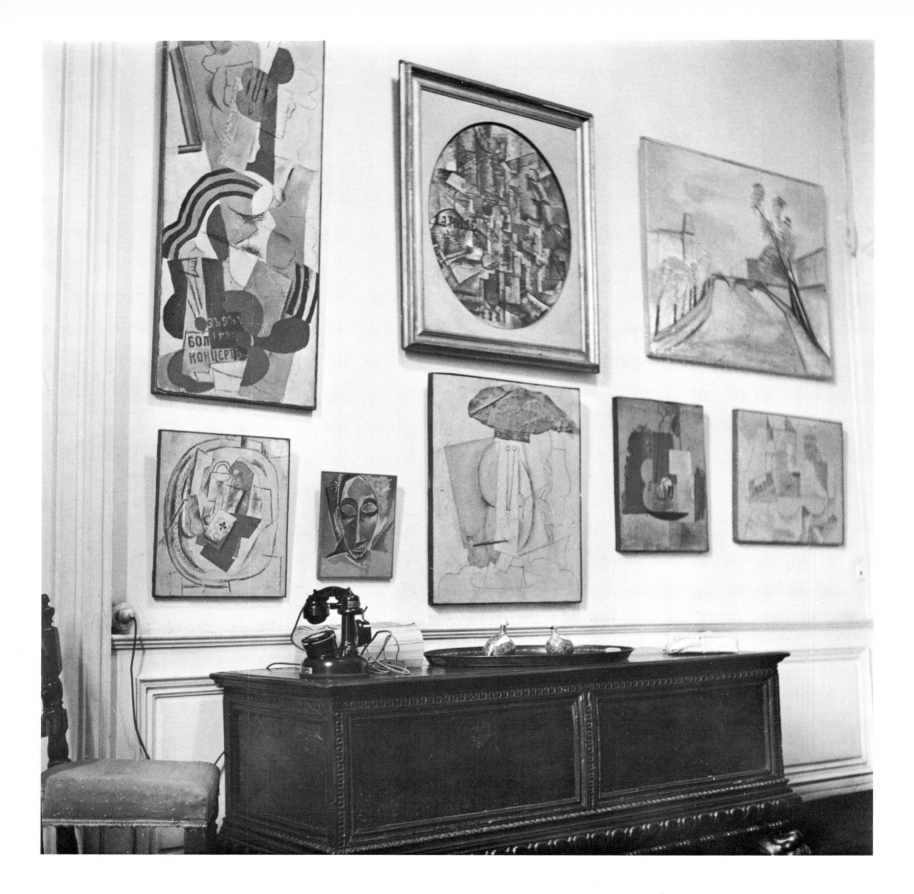

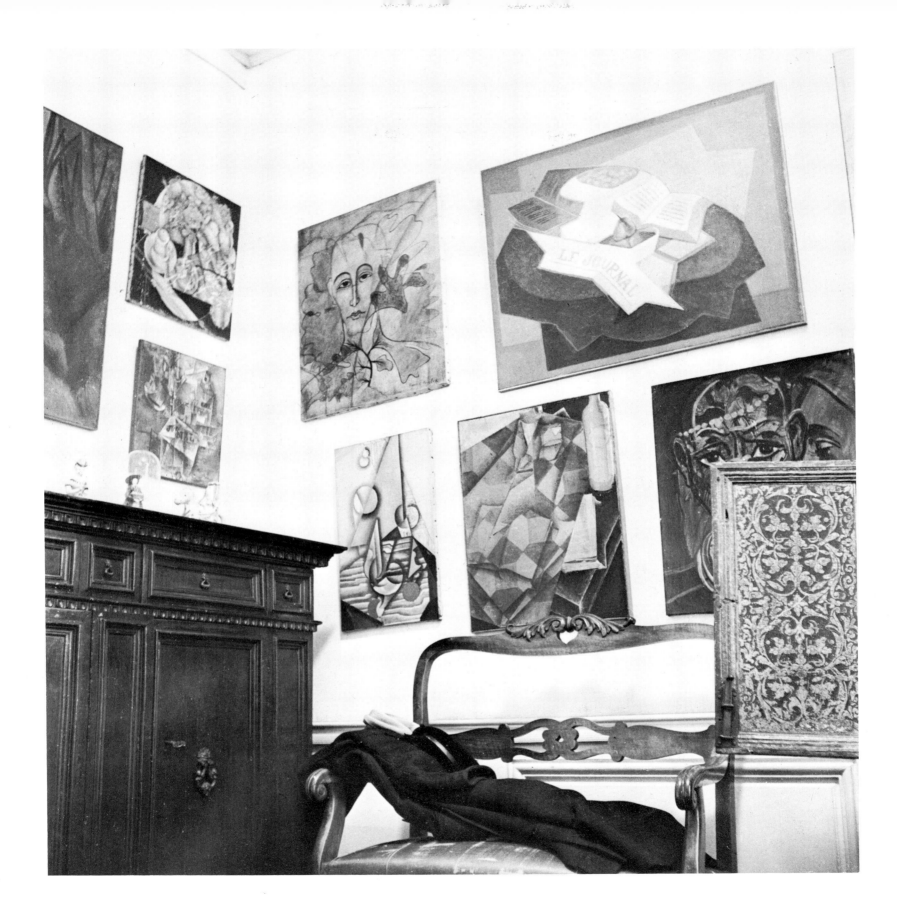

they did it, Picasso did it.

One must not forget that the earth seen from an airplane is more splendid than the earth seen from an automobile. The automobile is the end of progress on the earth, it goes quicker but essentially the landscapes seen from an automobile are the same as the landscapes seen from a carriage, a train, a waggon, or in walking. But the earth seen from an airplane is something else. So the twentieth century is not the same as the nineteenth century and it is very interesting knowing that Picasso has never seen the earth from an airplane, that being of the twentieth century he inevitably knew that the earth is not the same as in the nineteenth century, he knew it, he made it, inevitably he made it different and what he made is a thing that now all the world can see. When I was in America I for the first time travelled pretty much all the time in an airplane and when I looked at the earth I saw all the lines of cubism made at a time when not any painter had ever gone up in an airplane. I saw there on the earth the mingling lines of Picasso, coming and going, developing and destroying themselves, I saw the simple solutions of Braque, I saw the wandering lines of Masson, yes I saw and once more I knew that a creator is contemporary, he understands what is contemporary when the contemporaries do not yet know it, but he is contemporary and as the twentieth century is a century which sees the earth as no one has ever seen it, the earth has a splendor that it never has had, and as everything destroys itself in the twentieth century and nothing continues, so then the twentieth century has a splendor which is its own and Picasso is of this century, he has that strange quality of an earth that one has never seen and of things destroyed as they have never been destroyed. So then Picasso has his splendor. Yes. Thank you.

PRECEDING PAGES:

Left: Foyer of the rue Christine in 1956. The black renaissance plate on the table figures prominently in an amusing incident retold in The Autobiography of Alice B. Toklas. *Photograph by Ettore Sottsass.*

Right: Foyer of the rue Christine. In addition to the paintings by Picasso, the foyer had pictures by Juan Gris and Francis Picabia. Photograph by Ettore Sottsass.

TWO WORD PORTRAITS

PICASSO

One whom some were certainly following was one who was completely charming. One whom some were certainly following was one who was charming. One whom some were following was one who was completely charming. One whom some were following was one who was certainly completely charming.

Some were certainly following and were certain that the one they were then following was one working and was one bringing out of himself then something. Some were certainly following and were certain that the one they were then following was one bringing out of himself then something that was coming to be a heavy thing, a solid thing and a complete thing.

One whom some were certainly following was one working and certainly was one bringing something out of himself then and was one who had been all his living had been one having something coming out of him.

Something had been coming out of him, certainly it had been coming out of him, certainly it was something, certainly it had been coming out of him and it had meaning, a charming meaning, a solid meaning, a struggling meaning, a clear meaning.

One whom some were certainly following and some were certainly following him, one whom some were certainly follow-ing was one certainly working.

Top: THREE WOMEN, *Paris, 1908, Oil.*
The Hermitage, Leningrad.

Bottom: WOMAN WITH MIRROR
(Portrait of Fernande), Paris, 1909,
Oil. The Art Institute of Chicago,
Joseph Winterbotham Collection.

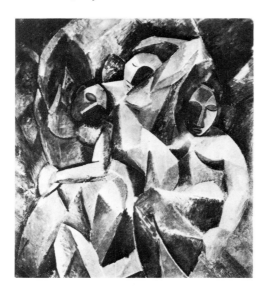

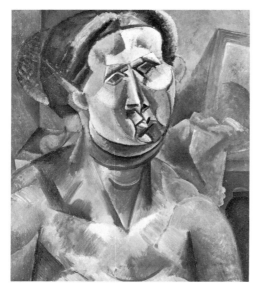

One whom some were certainly following was one having something coming out of him something having meaning and this one was certainly working then.

This one was working and something was coming then, something was coming out of this one then. This one was one and always there was something coming out of this one and always there had been something coming out of this one. This one had never been one not having something coming out of this one. This one was one having something coming out of this one. This one had been one whom some were following. This one was one whom some were following. This one was being one whom some were following. This one was one who was working.

This one was one who was working. This one was one being one having something being coming out of him. This one was one going on having something come out of him. This one was one going on working. This one was one whom some were following. This one was one who was working.

This one always had something being coming out of this one. This one was working. This one always had been working. This one was always having something that was coming out of this one that was a solid thing, a charming thing, a lovely thing, a perplexing thing, a disconcerting thing, a simple thing, a clear thing, a complicated thing, an interesting thing, a disturbing thing, a repellant thing, a very pretty thing. This one was one certainly being one having something coming out of him. This one was one whom some were following. This one was one who was working.

This one was one who was working and certainly this one was needing to be working so as to be one being working.

This one was one having something coming out of him. This one would be one all his living having something

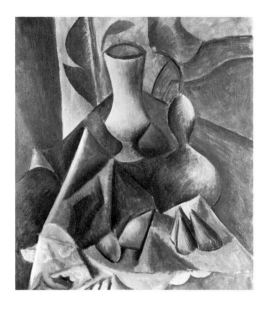

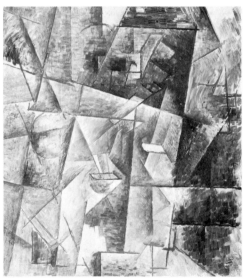

Top: GREEN STILL LIFE, *Paris, Spring 1909, Oil. Collection Mr. and Mrs. John Hay Whitney, New York.*

Bottom: THE LITTLE GLASS, *Paris, Spring 1912, Oil. Private Collection, New York.*

coming out of him. This one was working and then this one was working and this one was needing to be working, not to be one having something coming out of him something having meaning, but was needing to be working so as to be one working.

This one was certainly working and working was something this one was certain this one would be doing and this one was doing that thing, this one was working. This one was not one completely working. This one was not ever completely working. This one certainly was not completely working.

This one was one having always something being coming out of him, something having completely a real meaning. This one was one whom some were following. This one was one who was working. This one was one who was working and he was one needing this thing needing to be working so as to be one having some way of being one having some way of working. This one was one who was working. This one was one having something come out of him something having meaning. This one was one always having something come out of him and this thing the thing coming out of him always had real meaning. This one was one who was working. This one was one who was almost always working. This one was not one completely working. This one was one not ever completely working. This one was not working to have anything come out of him. This one did have something having meaning that did come out of him. He always did have something come out of him. He was working, he was not ever completely working. He did have some following. They were always following him. Some were certainly following him. He was one who was working. He was one having something coming out of him something having meaning. He was not ever completely working.

IF I TOLD HIM

A Completed Portrait of Picasso

If I told him would he like it. Would he like it if I told him.

Would he like it would Napoleon would Napoleon would would he like it.

If Napoleon if I told him if I told him if Napoleon. Would he like it if I told him if I told him if Napoleon. Would he like it if Napoleon if Napoleon if I told him. If I told him if Napoleon if Napoleon if I told him. If I told him would he like it would he like it if I told him.

Now.

Not now.

And now.

Now.

Exactly as as kings.

Feeling full for it.

Exactitude as kings.

So to beseech you as full as for it.

Exactly or as kings.

Shutters shut and open so do queens. Shutters shut and shutters and so shutters shut and shutters and so and so shutters and so shutters shut and so shutters shut and shutters

A 1950 portrait of Picasso. Courtesy Mr. and Mrs. Harold Knapik.

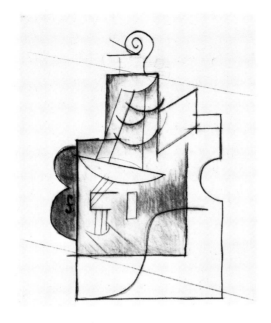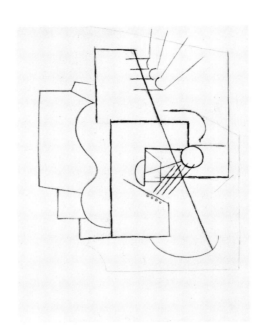

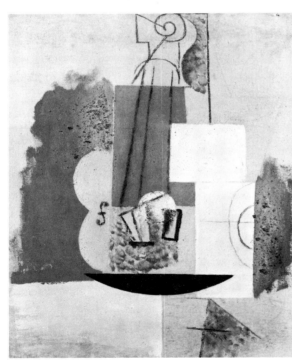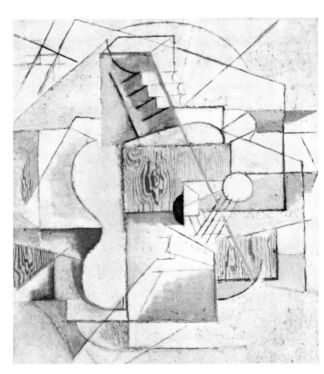

 and so. And so shutters shut and so and also. And also and so and so and also.

Exact resemblance to exact resemblance the exact resemblance as exact as a resemblance, exactly as resembling, exactly resembling, exactly in resemblance exactly a resemblance, exactly and resemblance. For this is so. Because.

Now actively repeat at all, now actively repeat at all, now actively repeat at all.

Have hold and hear, actively repeat at all.

I judge judge.

As a resemblance to him.

Who comes first. Napoleon the first.

Who comes too coming coming too, who goes there, as they go they share, who shares all, all is as all as as yet or as yet.

Now to date now to date. Now and now and date and the date.

Who came first Napoleon at first. Who came first Napoleon the first. Who came first, Napoleon first.

Presently.

Exactly do they do.

First exactly.

Exactly do they do too.

First exactly.

And first exactly.

Exactly do they do.

And first exactly and exactly.

And do they do.

At first exactly and first exactly and do they do.

The first exactly.

And do they do.

The first exactly,

 At first exactly.

85

Top left: STUDY FOR "THE VIOLIN," *Paris, Winter 1912, Crayon and charcoal. Marlborough Gallery, New York.*

Bottom left: THE VIOLIN, *Paris, Winter 1912, Oil, sand and charcoal. Private Collection, New York.*

Top right: STUDY FOR "GUITAR ON TABLE," *Paris, 1912–1913, Crayon drawing. Marlborough Gallery, New York.*

Bottom right: GUITAR ON TABLE, *Paris, 1912–1913, Oil, charcoal, and sand. Private Collection, New York.*

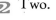First as exactly.

At first as exactly.

Presently.

As presently.

As as presently.

He he he he and he and he and and he and he and he and and as and as he and as he and he. He is and as he is, and as he is and he is, he is and as he and he and as he is and he and he and and he and he.

Can curls rob can curls quote, quotable.

As presently.

As exactitude.

As trains.

Has trains.

Has trains.

As trains.

As trains.

Presently.

Proportions.

Presently.

As proportions as presently.

Father and farther.

Was the king or room.

Farther and whether.

Was there was there was there what was there was there what was there was there there was there.

Whether and in there.

As even say so.

One.

I land

Two.

Left: WOMAN WITH MANDOLIN (with Russian Letters), Paris, 1914, Oil, sand, and charcoal. Collection Mr. and Mrs. David Rockefeller, New York.

Top right: STUDENT WITH A PIPE, Paris, Winter 1913–1914, Oil, charcoal, pasted paper, and sand. Private Collection, New York.

Bottom right: STILL LIFE WITH ACE OF CLUBS, Paris, 1914, Oil, pencil, charcoal, and pasted paper. Collection Mr. and Mrs. John Hay Whitney, New York.

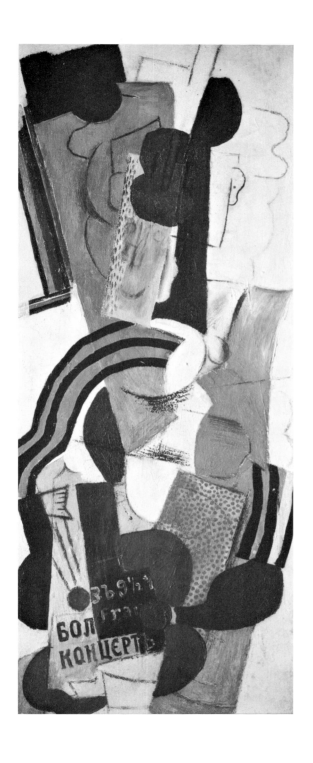

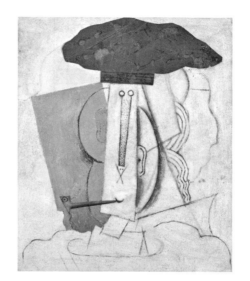

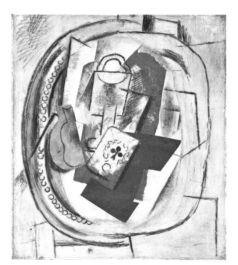

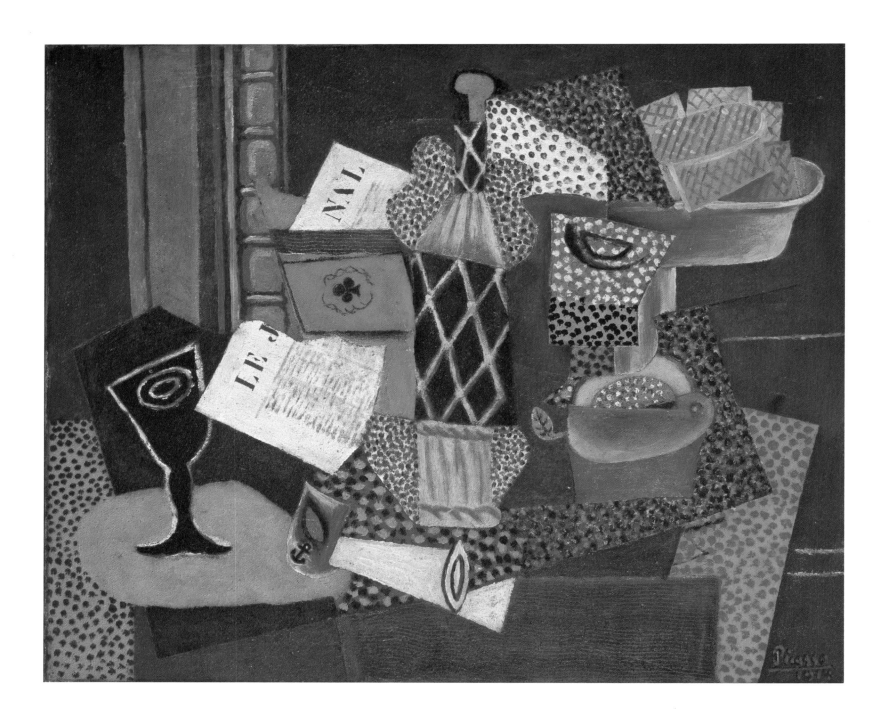

STILL LIFE *(Verre, Bouteille Rhum Paillée, Compotier sur une table) Avignon, 1914, Oil and charcoal. Collection Mr. and Mrs. John Hay Whitney, New York.*

MAN WITH A GUITAR, *Paris, 1913, Oil and wax. Collection Mr. André Meyer, New York.*

Gertrude Stein at the window of 5, rue Christine on V-E Day.

I land.
Three.
The land.
Three.
The land.
Three.
The land.
Two.
I land.
Two.
I land.
One.
I land.
Two.
I land.
As a so.
They cannot.
A note.
They cannot.
A float.
They cannot.
They dote.
They cannot.
They as denote.
Miracles play.
Play fairly.
Play fairly well.
A well.
As well.
As or as presently.

Let me recite what history teaches. History teaches.

FROM THE NOTEBOOKS

Note: In transcribing these entries the spelling and punctuation of the original have not been altered.

Matisse, Pablo and I do not do ours with either brains or character we have all enough of both to do our job but our initiative comes from within a propulsion which we don't control, or create.

Pablo so much dirtier than Raymond [Duncan] or Hutch [ins Hapgood]. they cleaner sexual tabby goes to weakness, dirtier goes to pathology. . . . dirty Bazarof. Pablo most genial Bazarof and dirtier.

Bazarofs are not critical they have no touch stone for reality. They have reality and arrogance in themselves and the combination makes them not susceptible of reality in others. Pablo is the highest type of it because being low he has

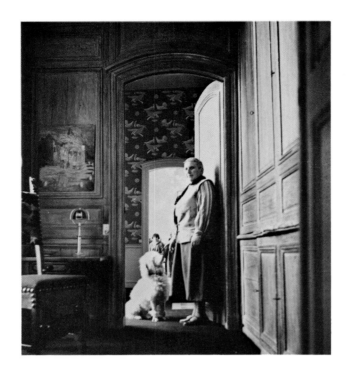

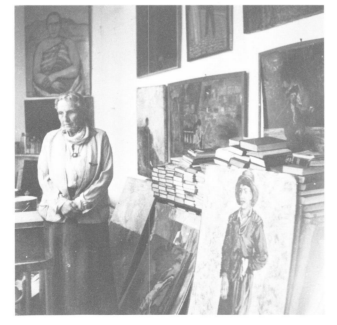

most reality. I believe he will work out of submission to unreality.

The Bazarofs are not slow they are blind, they are facile they learn really easily, but they are blind. Pablo's instinct is right, he does not wish to slow himself but to concentrate himself.

I am quite sure that it is true of Matisse that he cannot do pure decoration because he has to have the practical realism of his group as his point de depart always. He must paint after nature, his in between decorative period was and is a failure, it is only carried by his beautiful colors and his power in drawing but they have no real existence. He has always failed in such flat painting, he then of course not understanding his own failure cannot understand Pablo who succeeds in just this. I sometimes think that Matisse has done what Van Gogh tried to do and what Pablo will do what Goguin dreamed of. It is very interesting that the dramatic independent dependents [i.e. Matisse's type] have no lyric or decorative sense. You must have them . . . where the sensitiveness becomes creative not the drama & consequently where the practical sense is not dominant.

. . . Now all these people do not get their inspiration from their relation direct to the object but from their affection for the object. . . . This people get their sense again not from immediate contact with the object but from a passionate emotion

96

Top: Gertrude Stein, Alice B. Toklas, and Basket II in the rue Christine, 1945. Photograph by Cecil Beaton.

Bottom: Gertrude Stein in the gallery of the rue Christine. This 1946 photograph shows the Picabia portrait and works by Sir Francis Rose. Photograph by Cecil Beaton.

APPLE, *Paris, 1914, Watercolor. Collection Mr. and Mrs. David Rockefeller, New York.*

about the object. That is the reason all these have a dramatic, a practical and a crudely material imagination and of these Matisse is the great creator. He truly said he painted his emotion but in order to paint it he had to have it attached to the crudely materialistic object when he gets away from this he is lost. He still makes lovely but not significant painting. Now Cezanne is the great master of the realization of the object itself, Pablo connects on to him. Renoir on the contrary is in direct relation so to speak with the beauty of the object. . . . [Pablo's type] are to a more or less degree in actual creative relation to the object. . . . This is what Pablo probably meant when he said that Matisse always gave the crude feeling of the object but he never really paints the object.

. . . all Bazarofs are in essence ethical and fanatical, not by reason of their affection for object but by reason of their realisation of symbolism, Pablo is saved from that because it is it itself that makes it symbolic to him, he does not partly generalize it as do all the Bazarofs. . . .

. . . Pablo & Matisse have a maleness that belongs to genius. Moi ausi perhaps.

* Nadelman like Leonardo when he is a scientist he is not an artist. Pablo and Michael Angelo are artist every moment of their being. Matisse and Delacroix are scientists only for the purposes of art never for the purposes of science.

Left: Gertrude Stein and Alice B. Toklas in 1936 in the garden of Bilignin. Photographed by Cecil Beaton.

Right: Gertrude Stein in 1936 in the salon of the house at Bilignin. Photograph by Cecil Beaton.

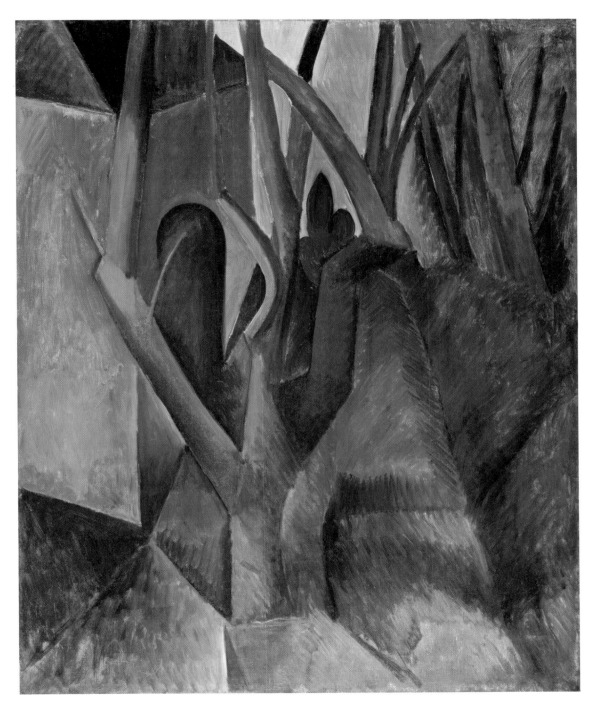

LA RUE DE BOIS (*près Verneuil, Oise*),
*1908, Oil. Collection Mr. André
Meyer, New York.*

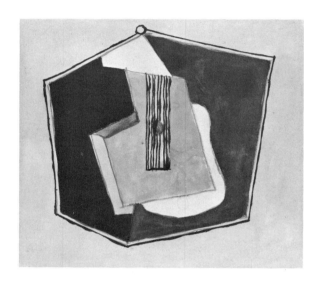

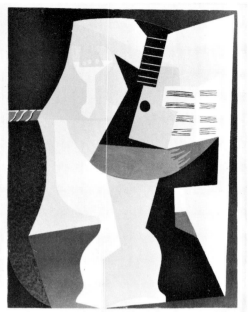

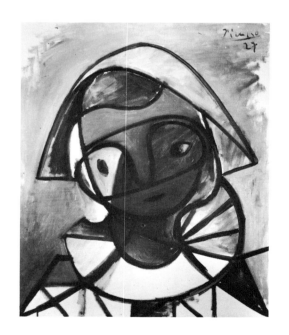

When Matisse & Pablo met they both said how the other had grown old.

Do one about Pablo his emotional leap and courage as opposed to lack of courage in Cezanne and me. His laziness and his lack of continuity and his facility too quick for the content which ought to be so complete to do what he wants to do. Too lazy to do sculpture. His work is not because it is too strong for him to resist but because his resistance is not great enough. Cezanne resistance great but dragged along. Pablo is never dragged, he walks in the light and a little ahead of himself like Raphael. therefore his things often lack a base. Do him.

One whom some were certainly following was one who was completely charming.

Left: GUITAR, *Paris, 1918, Watercolor. Collection Mr. and Mrs. David Rockefeller, New York.*

Top right: TABLE WITH GUITAR AND PARTITION, *Juan Les Pins, 1920, Gouache. Collection Mr. and Mrs. Gilbert W. Chapman, New York.*

Bottom right: PORTRAIT OF THE ARTIST'S SON, *1927, Oil. Collection of the Artist.*

Matisse blindness, unreasonableness, he is unreasonable on account of the tenacity with which he holds to his central idea himself and his art, he can change slowly it is not with him an inner contradiction, there is no inner contradiction, it is the dogged persistence of the thing that for the time he knows, in Pablo and in Raymond—Hutch, . . . it is the domination of the mystic idea to the denial of their intellect and their experience. Matisse never denies his experience, he continually affirms it, so in him there is no contradiction, there may be a doubt of it, a terror of losing or having lost it . . . but his whole life is the affirmation of his experience. the danger with the [Bazarof] fanatic group is the denial of their experience, this may make them moral enthusiasts. . . . it may make them, aesthetic

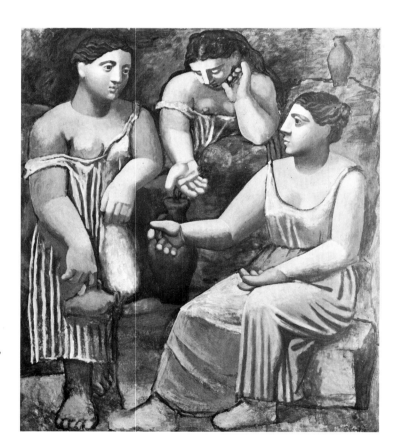

Top: STILL LIFE WITH CALLING CARD,
Paris, 1914, Pencil and pasted papers.
Collection Mrs. Gilbert W. Chapman,
New York.

Bottom: THREE WOMEN AT THE
SPRING, *Summer 1921, Oil. The*
Museum of Modern Art. Gift of Mr.
and Mrs. Allan D. Emil.

 visionaries as Raymond & (I hope not) Pablo Pablo
may be saved by the intensity of his actual aesthetic experi-
ence, if he can hold to that he will go on . . . but it is this quality
in them that so often makes their genius sterile. . . . and so there
are innumerable ways of ship-wreck.

AFTERWORD

"THEY WALK IN THE LIGHT"

Gertrude Stein
and Pablo Picasso

Leo and Gertrude Stein, arriving in Paris at the opening of the twentieth century, moved directly into the center of the Paris revolution in painting. They became the first major supporters and collectors of this revolution. Their home, at 27 rue de Fleurus, is justly recognized as the first museum of modern art. It was there that on any given Saturday night an international gathering of artists and visiting friends would come to gaze at the walls of the studio, covered from *cheminee* to the ceiling with the works of Picasso, Matisse, Cezanne, Renoir, Delacroix, Gauguin, Manet, Manguin, Vallotton, Marie Laurencin, and others. Later, after Leo left and the apartment was shared by Gertrude Stein and Alice Toklas, works by Juan Gris, Marsden Hartley, Francis Rose, Riba Rovira, Dora Maar, Francis Picabia, and a score of other artists were added.

Leo's and Gertrude's interest in painting began long before their arrival in Paris. Since their student days at Johns Hopkins, Leo had been painting and collecting, and Gertrude had been learning about art almost solely under his tutelage, but several steps behind.

But Gertrude, arriving later, stayed longer. Leo's appetite for "Cubist funny-business" diminished rapidly after the break with his

109

sister in 1911; Gertrude remained in close rapport with a succession of Paris painters—as collector and connoisseur, somewhat as friend, and most importantly as an artist whose own art paralleled and was influenced by theirs.

Her most profound and lasting friendship among the artists was with Pablo Picasso.

The story of Leo's and Gertrude's meeting with Picasso has been told almost too often. Leo, who ceaselessly visited every out-of-the-way art gallery in Paris, had come upon Picasso's work in November 1905 at the shop of the clown turned picture dealer, Clovis Sagot. Some days later, Leo and Gertrude visited Sagot's and purchased the early rose period picture *Girl With a Basket of Flowers*.

Picasso had apparently already seen the two Steins at a distance at Sagot's and, struck by Gertrude's appearance, he commented to Sagot that he would like to do her portrait. It was the first time in some years that he was interested in doing formal portraiture *because* of the model, intending to treat her not as incidental to the painting but as the point of it. During the "eighty or ninety sittings" that Gertrude underwent, he apparently held to his intention of finishing a formal portrait of her. However, when the sittings were over, he painted out her face. When, in the following autumn, he substituted a mask-like reduction of her features for the face, the painting joined his other portraiture of these early years in being interesting only secondarily for its subject.

When Gertrude met Picasso she thought he was beautiful. He was about twenty-four with an almost overwhelming vitality in his sturdy, well-knit body. He possessed a kind of luminous glance that darted everywhere and pierced everything, a richness and fullness of seeing that was exactly like Gertrude's own. They were extremely happy together, talked easily and sweetly with an unrestraint that had less to do with a meeting of minds than a meeting of natures.

For years Gertrude was to watch Picasso with the closest attention, worrying over his shifts of mood and over what she thought of as his betrayals of his real self. Her notes betray her anxiety as she watched Picasso skirt the traps of his temperament. She is never unsure of her analysis of Picasso. Her comment on him is based on a certainty that grew out of complete absorption in his problems, both personal and creative, and out of a complete identification with his struggles.

110

Top: A visitor entering the atelier of the rue de Fleurus in 1914 faced a formidable array of Picassos, dominated by his portrait of Stein.

Bottom: On the adjacent wall, more Picassos and the Cézanne Portrait of Madame Cézanne.

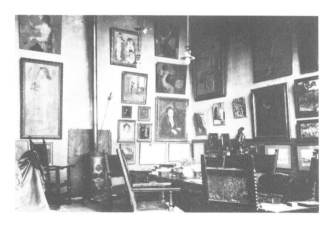

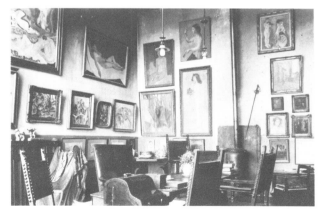

Gertrude's discernment of him is subtle and various. She saw Picasso so much in the round that her portrait of him is as critical as it is flattering. She plainly assumes that he is doomed to live permanently with his "Spanish tragedy." What for her is open to question is whether his character and his deepest nature might in some way permanently cripple or divert his art.

Gertrude thought of Picasso as a "Basarof" (Turgenev's *Fathers and Sons*). Basarofs possess "reality" and arrogance and so are not susceptible to the reality in others. It is important to them to remain opaque; this is their method of concentrating their experience and themselves. The danger for them lies in fanaticism on the one hand and "dirtiness" on the other. The fanatic is dominated by a "mystic idea" which leads finally to the denial of the individual's own experience and understanding. "It may make them aesthetic visionaries as Raymond [Duncan] and (I hope not) Pablo. Pablo may be saved by the intensity of his actual aesthetic experience, if he can hold to that he will go on."

But like Turgenev's Basarof, these assertive and visionary types, no matter how genial, possess a *sale* sexuality. Such a bottom nature does not necessarily result in promiscuous and *sale* sexual adventure; it could as easily end in a rigidity of temper designed to petrify the sexual nature. Though he is the most genial kind of Basarof in sexual nature, she writes, Picasso is nevertheless very dirty.

It was Gertrude's prayer that this extreme of sexuality would counterbalance his Basarofian aesthetic mysticism. In her book on Picasso one can still discern this original analysis of his temper. She describes the success of his work in terms of self-correction, his alternate natures dominating in turn and provoking their successive contradictions.

But essentially Picasso was in control. That is to say, the impelling force of his behavior was not either his sexuality or his intellect but his instinctive creativity. Creativity was predicated, for Stein, on one's relation to the world, not to oneself; and in the rare instances when a human being was more "in existence" in relation to the world than to himself, he approached genius or, to put it another way, the condition of complete consciousness. Picasso represented for Gertrude the greatest realization of this complete consciousness she had ever known.

The studio of the rue de Fleurus in 1914. With each new acquisition, Stein would call for the concierge and days would be spent rearranging the walls. Every few months, the process would be repeated.

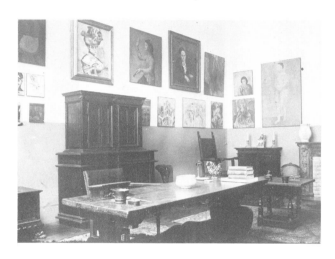

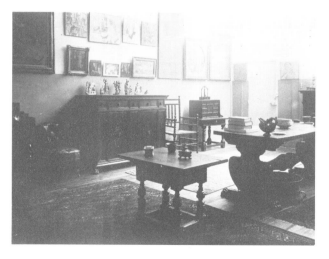

Do one about Pablo his emotional leap and courage as opposed to lack of courage in Cezanne and me. His laziness and his lack of continuity and his facility too quick for the content which ought to be so complete to do what he wants to do. Too lazy to do sculpture. His work is not because it is too strong for him to resist but because his resistance is not great enough. Cezanne resistance great but dragged along. Pablo is never dragged, he walks in the light and a little ahead of himself like Raphael. therefore his things often lack a base. Do him.
 One whom some were certainly following
 was one who was completely charming.

Stein's first portrait of Picasso was written in 1909 during a period of intense work on her monumental novel *The Making of Americans*. The pervasive force of this portrait lies in its use of repetition to confront the fundamental bottom nature of Picasso's personality as Stein understood it. In this portrait Stein repeats, yet always with a slight variation, the essence of Picasso the creator. He is, for her, someone who is creating clear images—images (ideas) which are drawn forth from his own inner struggle—not mirrored images of others. The emphasis in this portrait is on Picasso's struggle to express himself, to bring forth his own inner images. Throughout this portrait, and in fact in all her subsequent writings on or observations about Picasso, Stein stresses the central fact that for Picasso the inner struggle, the act of creation, is always of supreme importance. Her view of Picasso as creator is evident even in the earliest entry from the notebooks, quoted above.

"If I Told Him: A Completed Portrait of Picasso," is, at first glance, a more hermetic work. Written in 1923, this piece reveals Stein's total distillation of the portraiture form. The earlier expansiveness is gone; instead, Stein consciously forces the mind away from the expected word combinations. In doing so she has brought the portrait to its essence.

Clearly, this portrait concerns itself with Stein's displeasure with various aspects of Picasso's work. She opens by posing a question to herself: "If I told him would he like it. Would he like it if I told him." What is it that she feels compelled to tell him? Is it her lack of enthusiasm for his involvement with neo-classicism, his flirtation with literature? "Would he like it would Napoleon would Napoleon would he like it." Napoleon is Picasso, but Stein uses the name not

to evoke associations and symbols, but merely to invoke the image of Picasso, who, when surrounded by his friends Andre Derain, Georges Braque, Guillaume Apollinaire, and Andre Salmon, was like a small toreador and reminded Stein of Napoleon surrounded by his guards.

At first determined to confront Picasso "Now," she soon hesitates and decides, "Not now." There is in her mind the thought that this challenge to Picasso's true artistic nature will pass and that he will return to the art of pure creation, abandoning the neo-classicism of his Italian period and his efforts to write poetry and plays. The questioning finally resolved itself in her mind with the decision to "Have hold and hear." Having reached this decision she can relax. There is word play, and playing with word sounds develops. Soon the landscape intrudes into her thoughts and the nearby waves lapping on the shore enter the portrait.

> *Whether and in there.*
> *As even say so.*
> *One.*
> *I land.*
> *Two.*
> *I land.*
> *Three.*
> *The land.*

The portrait ends enigmatically with Stein posing the unanswered question, "Let me recite what history teaches. History teaches." Her faith in Picasso is so firm that she can be critical of aspects of his work without any question of her loyalty to him. The lack of enthusiasm in this portrait is for a fleeting period of the artist's creative life, not for the artist himself.

One must be cautious in appraising the relation between the art of Picasso and that of Gertrude Stein. In her understanding, they shared an identical orientation toward the most significant problems of art, but certainly none of manner or *metier* and certainly none based on the writer's imitation of the painter's solutions. This can be understood initially, perhaps, by recalling Picasso's revision of the *Portrait of Gertrude Stein* after the "eighty or ninety sittings" Gertrude re-

The first two pages of the manuscript for the French edition of Picasso. *Courtesy Yale University Library, Gertrude Stein Collection.*

ports she endured for the original version. The Iberian mask Picasso substituted for the head continued to resemble Gertrude's face—in fact, continued to be a portrait in the ordinary way. The recognizable characteristics of the face and head are rendered so severely that they lose all mobility, and the eyes are generalized so that they lose personal expression. The head is both Gertrude's head *and* its reduction to a mask.

The Iberian figures shown at the Louvre exhibition (spring 1906) before Picasso left for Spain were the source of this new formality in his work. The *Peasants from Andorra* and the *Woman with Loaves*, both painted in Spain during the summer of 1906, carried the first suggestion of this way of "stating" or signifying a portrait. Within the context of the painting, the mask was both iconography and a "thing" in its own right. The reductive vocabulary of the mask is emphatically objectified. Device, in a sense, becomes object. Directly after the portrait of Gertrude, Picasso began the series of studies which were to culminate the following spring in *Les Demoiselles d'Avignon,* in which, among other culminations, the new mask portraiture was to reach its ultimate development and bring Picasso to the threshold of Cubism.

Without knowing it, in the years before 1908, Stein's work was moving precisely in the direction of Picasso's painting. This movement was toward describing reality in terms of an iconography of such pervasive force that it commands aesthetically a position in the composition equal to the objects it describes. Gradually, the iconography becomes not the element that subsumes the composition, but itself the primary element out of which the composition is made.

Gertrude Stein thought the major painting and her own writing of these years (roughly 1902 to 1912) "ugly" and "brutal"—creations which show frankly their record of struggle. Her whole sense of the period, and of the aura that surrounded these heroic years of seminal work, is based on her recognition of the "ugly giants" created then by Matisse, Picasso, and herself. The "brutality" of each of their works comes from the process that created them—the successive "shucking-off" of old habits of seeing and rendering—and this process results in the ultimate emergence of a new art. Stein, like Picasso, attacked the remnants of the traditional viewpoint in art that held certain logical constructs as the basis for all creation. The resultant

Two manuscript pages of the 1909 portrait, "Picasso." Courtesy Yale University Library, Gertrude Stein Collection.

work, however, is never the end, but the record of the process—the record of vigorous, passionately sustained, successive attacks at the solution of a retreating problem. "Real thinking is conceptions aiming again and again always getting fuller, that is the difference between creative thinking and theorising."

To perceive the sense in which Gertrude saw her own work and Cubist painting as engaged in the same "struggle," we must stare at a banal fact: cubist compositions represent particular objects, every one of them showing certain persons, places, and things. Further, the compositions *merely* represent them, with neither allegory nor emotion, and with no attempt to generalize their significance. No matter how opaque, convoluted, turgid, or disoriented the particular thing may become, it is always a thing and nothing more; nor is it shown for the purpose of exploiting the object thematically.

Gertrude's whole anxiety concerning Picasso's outcome as an artist was rooted in one essential question: will anything in his makeup interfere with his love of "object as object"? Stein, in writing about Picasso, may speak of his "styles," his "concepts," or his "periods"; but one question and one alone rivets her attention: What is Picasso's present "relation to the object"? The "objects" she and Picasso are concerned with are naturally as different as the diversity between the writer's and the painter's concerns. Hers are with human beings, their patterns of behavior and relations; his with visible phenomena. But she realized that the intensity and impersonality of investigation necessary to both painter and writer were the same. The unabating zeal that finally wrests from these different concerns their "reality" is for her the primary activity that goes on in writing and painting. The evidence in the work of the realization of this zeal is for her the absolute criterion of its excellence. Art that has any intention other than to bring the "object as object" to full realization is to her mind secondary; and art that loses the particular object as its central focus is to her mind immoral: "The moment art becomes abstract, it is pornographic." The highest art is the highest realization of the most complex objects: "the final test is always the portrait."

Gertrude Stein, as a passionately involved partisan in the Cubist moment, wrested a formulation from the struggles of that moment which had a significant impact on the structuring of her work. Roughly, her formulation was this: "to kill the nineteenth century"

the art of this century—painting and writing—must organize compositions that are "de-centralized," object-oriented, and expressed in a conceptual iconography which itself ultimately becomes the object of the composition.

In their respective arts, both Stein and Picasso sought to set the mind free to envision the act of creation which for them was the first concern of the moment. Together they pushed innovations in their respective crafts higher and farther than anyone expected. Respectively, they aimed for a level of creation at which art and writing would remain art and writing—not seeking to be science, philosophy, or history. In *Picasso* Stein offers what may well be regarded as the final epitaph for both.

> A creator is not in advance of his generation but he is the first of his contemporaries to be conscious of what is happening to his generation.
>
> A creator who creates, who is not an academician, who is not some one who studies in a school where the rules are already known, and of course being known they no longer exist, a creator then who creates is necessarily of his generation.

<div align="right">LEON KATZ and EDWARD BURNS</div>

June, 1970

A NOTE ON THE TEXTS

The 1909 portrait "Picasso" first appeared in the August 1912 issue of *Camera Work*. Later it was reprinted in a special issue of that magazine together with Stein's portraits of Matisse and Cezanne. "Picasso" was also included in *Portraits and Prayers* (1934). The 1923 portrait, "If I Told Him: A Completed Portrait of Picasso," first appeared in *Portraits and Prayers*. The texts used in this edition come from that volume.

Picasso (1938) was written originally in French and first published by Librairie Floury, 14, rue de l'Universite, Paris. To write in French was a significant departure from Stein's usual habit; except for some correspondence and an occasional short piece or catalog introduction she preferred to do all her work in English. Her written and spoken French were totally fluent; however, even after years of living in France her accent retained its distinctive California flavor. It was Miss Alice Toklas who once remarked to a young American girl who had been living in Paris and who spoke perfect French, "You must be staying with the wrong people."

The manuscript of *Picasso* was worked over with great care, and typescripts were sent to Stein's friends Daniel-Henry Kahnweiler and the Baronne Pierlot for their corrections. The typescripts, with their additions and corrections, are now in the Gertrude Stein Collection

at Yale University. Neither the division into chapters nor the footnotes in the French edition were done by Gertrude Stein or Alice Toklas. Stein wrote to her friend W. G. Rogers: "There are going to be lots of dates and foot-notes just like a real book. Escholier [the French editor] insisting upon that, so I am letting them put them in not having the habit . . ."

Sometime in 1938 Stein was approached by the British firm of B. T. Batsford, Ltd. for an English edition. The task of translating the French manuscript fell to Alice Toklas. She used as her guide the original French manuscript, freely adapting it. The first draft of the translation offered Stein the choice, here and there, of several English possibilities for the French wording. This first draft was carefully reworked by Stein and Toklas and then a typescript prepared. This version, too, was then revised. In preparing this new edition of *Picasso* I have attempted to collate all known drafts of the manuscripts. Here and there I have adopted the punctuation of the original manuscript because it was clearly Stein's intent. Obvious printing errors have been corrected, and in two instances parts of sentences worked into all drafts but not into the printed edition have been restored. The form of certain words has been retained since this was clearly the intention of the author.

At Alice Toklas' request her own role in the development of this book was not mentioned. No scholar who has had the opportunity to work on the Stein manuscripts at Yale University can ignore the role of Alice Toklas in Gertrude Stein's work. For the first time, in this edition, that role has been acknowledged.

It was Thornton Wilder who warned Gertrude Stein in 1936 to get her unpublished manuscripts into the safekeeping of the Yale Library because of the danger of another world war breaking out on French soil. Stein packed several cases of material consisting of manuscripts, letters, and miscellany and sent them off. The packing was done with characteristic Steinian abandon: neatly piled manuscripts were dumped into crates, and drawers of correspondence, carefully alphabetized and filed at the end of each year by Alice Toklas, were pulled out and overturned into the boxes. Finally, all the scraps of paper that Gertrude never threw away—budget lists, garage attendants' instruc-

tions about the Fords she owned, forgotten old bills—were tossed in, too. Alice remonstrated about their inclusion, but Gertrude used every hoarder's excuse: "You can never tell whether some laundry list might not be the most important thing."

An assortment of copybooks and loose pages lying among chunks of the manuscript for the novel, *The Making of Americans,* fell into the crates along with all the other papers. Gertrude had forgotten what they contained, and Alice had never seen them and merely assumed they were part of the manuscript. When this material was sorted at Yale some time later, a mound of notebooks small enough to push into one's pocket and one or two schoolchildren's copybooks came to light. Sheets from the little books were found in the original manuscripts of *The Making of Americans* and the other works concurrent with it. These pencilled scrawls were the writing notes and comments Gertrude had made to herself, never intended to be seen by anyone and so recorded without any self-conscious concern for the bluntness of their style or the injudicious nature of their content. They were the notes from which she worked directly for most of her writing from 1902 to 1911.

These notebooks were transcribed by Leon Katz, who then spent several months (1952–1953) in Paris with Alice Toklas drawing upon her vast store of memories and recollections to annotate the entries. This edition of *Gertrude Stein on Picasso* marks the first publication of a substantial sampling of these notebooks.

EDWARD BURNS

119

ACKNOWLEDGEMENTS

I wish to express my deepest gratitude to all the private collectors, directors, and staff members of museums and art galleries who have, through their invaluable cooperation and interest, made this new edition of Gertrude Stein's writings on Picasso possible. With the exception of those who wish to remain anonymous, the names of the collectors figure in the catalog of illustrations or the captions to the photographs.

Betty Binns, Madelaine Caldiero, Beverley DeWitt, Samuel Melner, and Gary Whitcraft worked with devotion and love on the editing, design, and production of this book. The Museum of Modern Art has cooperated with this project in making available various materials related to the estate of Gertrude Stein acquired by a group of friends of the Museum. Without this cooperation this book could not have appeared in its present format.

Leon Katz kindly consented to make available to me his transcriptions of the Stein notebooks and worked diligently in the preparation of "They Walk in the Light": Gertrude Stein and Pablo Picasso.

I am especially grateful to those who have put at my disposal their personal archives or have provided indispensable information and assistance.

Mr. Cecil Beaton, London.
Mr. and Mrs. Antoine Chapman, Paris.

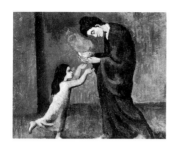

MOTHER AND CHILD *(La Soupe)*
page 10
Barcelona, 1902
Oil on canvas
Size: 14½ x 17¾ inches
Signed two thirds down right: Picasso
Coll. Mr. and Mrs. J. Harold Crang,
Toronto

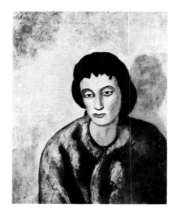

WOMAN WITH BANGS *page 10*
Barcelona, 1902
Oil on canvas
Size: 23⅝ x 19¼ inches
Signed top left: Picasso
Coll. The Baltimore Museum of Art,
Cone Collection

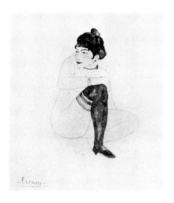

**SEATED NUDE WITH
GREEN STOCKING** *page 5*
Barcelona, 1902
Watercolor on biege paper
Size: 11⅞ x 7⅞ inches
Signed bottom left: Picasso
Private Collection, Paris

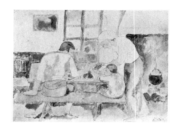

FAMILY AT SUPPER *page 12*
Barcelona, 1903
Ink and watercolor on paper
Size: 12½ x 17 inches
Signed bottom right: Picasso
Coll. Albright-Knox Art Gallery,
Buffalo, New York. Room of
Contemporary Art Fund

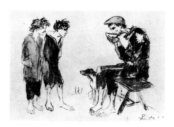

THE BEGGARS MEAL *page 12*
Barcelona, 1903–1904
Watercolor
Size: 9⅝ x 13⅝ inches
Signed bottom right: Picasso
(Note: The signature is later)
Private Collection, Paris

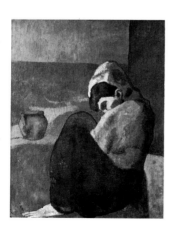

SEATED WOMAN WITH HOOD
page 10
Barcelona, 1902
Oil on canvas
Size: 34⅝ x 27⅜ inches
Signed top right: Picasso
Verso: Mother and Child, 1905
Coll. Staatsgalerie, Stuttgart

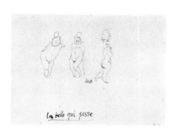

LA BELLE QUI PASSE *page 13*
1904
Ink on paper
Size: 11 x 15 inches
Signed lower right: Picasso
(Note: The signature is later)
Coll. Mr. and Mrs. Daniel Saidenberg,
New York

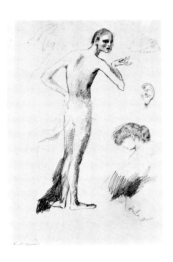

STUDY FOR "THE ACTOR" WITH
TWO PROFILES OF FERNANDE
page 23
Paris, Winter 1904–1905
Pencil on paper
Size: 18½ x 12⅜ inches
Signed bottom left: Picasso
Private Collection, New York

Note: The two sketches of heads are
probably the first portrayals of Fer-
nande in Picasso's work.

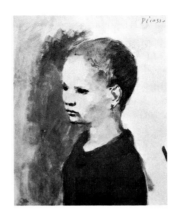

BUST OF A LITTLE BOY *page 31*
Paris, 1905
Gouache
Size: 12 x 9⅜ inches
Signed top right: Picasso
*Coll. The Baltimore Museum of Art,
Cone Collection*

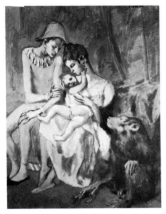

THE ACROBAT'S FAMILY
WITH A MONKEY *page 16*
Paris, 1905
*Gouache, pastel, and India ink
on cardboard*
Size: 41 x 29½ inches
Signed top right: Picasso
*Coll. The Gothenburg Art Gallery,
Gothenburg, Sweden*

Note: This, undoubtedly, was the first
picture by Picasso that Leo Stein saw
while investigating the shop of Clovis
Sagot, the clown turned art dealer, on
the rue Laffitte. It was purchased soon
after Leo and Gertrude bought the
Girl With A Basket of Flowers.

CIRCUS FAMILY *page 44*
Paris, 1905
Watercolor and India ink on paper
Size: 9½ x 12 inches.
Signed bottom right: Picasso
*Coll. The Baltimore Museum of Art,
Cone Collection*

COMPOSITION BLEU AU POUSSIN
page 20
Paris, 1905
Wood engraving
Size: 5¼ x 4⅜ inches
Unsigned
*Coll. Mr. and Mrs. John Hay
Whitney, New York*

COMPOSITION ROUGE
AU VAUTOUR *page 20*
Paris, 1905.
Wood engraving
Size: 5⅝ x 4½ inches
Unsigned
Private Collection, New York

traits of two men in top hats. Clearly visible, though painted over, are three figures similar in the general curve of the line to the mother in *Mother and Child (La Soupe)*.

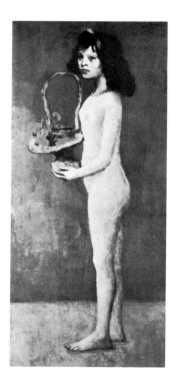

GIRL WITH A BASKET
OF FLOWERS *page 9*
Paris, 1905
Oil on canvas
Size: 61 x 26 inches
Signed top right: Picasso
Inscribed and dated on back:
Picasso / 13 rue Ravignan / 1905
Coll. Mr. and Mrs. David Rockefeller,
New York

Note: This is the first picture by Picasso purchased by Leo and Gertrude Stein. It was bought from Clovis Sagot, the picture dealer, in 1905 for 150 francs. Shortly afterwards the Steins met the artist at Sagot's—it was at that meeting that Picasso asked Gertrude Stein to pose for him.

The verso of this picture contains three other works that are clearly by Picasso. They have been, in two cases, painted over and are visible only with X-rays. They are: a portrait of a woman, similar to the portrait of the *Seated Nude* now in the Museé National d'Art Moderne, Paris, and por-

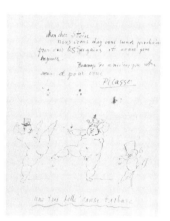

LETTER TO LEO STEIN *page 22*
Not dated (Probably 1905)
Pen and ink
Size: 11¼ x 15⅛ inches
Coll. Mr. and Mrs. Perry T. Rathbone,
Cambridge, Mass.

Translation: "My dear Stein / We will be at your place before dinner next Monday to look at the Gauguins. / Much friendship to you and your sister. / Picasso / A very beautiful barbaric dance."

Note: In the spring of 1905 Vollard announced a show of Gauguin where, for the first time, Leo and Gertrude Stein saw the painter's work. In *The Autobiography of Alice B. Toklas* she has written: "They were rather awful but they finally liked them, and bought two Gauguins. Gertrude Stein liked his sun-flowers but not his figures and her brother preferred the figures." The Steins purchased *Still Life with Sunflowers*, 1901, (now in the Buhrle Collection, Zurich), and *Three Women Against a Yellow Background*, 1899, (now in The Hermitage).

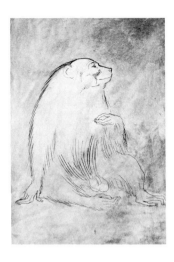

MONKEY *page 21*
Paris, 1905
Watercolor and ink
Size: 19¾ x 12⅝ inches
Unsigned
Coll. The Baltimore Museum of Art,
Cone Collection.

PORTRAIT OF GUILLAUME
APOLLINAIRE *page 28*
Paris, 1905
India ink on paper
Size: 12¼ x 9 inches
Signed bottom right: Picasso
(Note: The signature is later and is in
blue conté crayon)
Coll. Lionel Prejger, Paris

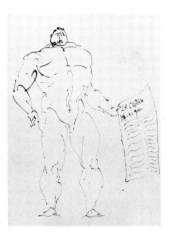

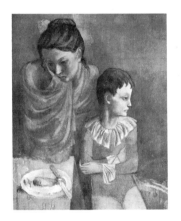

MOTHER AND CHILD *(Saltimbanques)*
page 16
Paris, 1905
Gouache on canvas
Size: 34⅝ x 27⅜ inches
Unsigned. (Signed recto)
Recto: Seated Woman With Hood,
1902
Coll. Staatsgalerie, Stuttgart.

SEATED NUDE *page 31*
Paris, 1905
Oil on cardboard mounted on panel
Size: 41¾ x 30 inches
Signed bottom right: Picasso
Coll. Musée National d'Art Moderne,
Paris

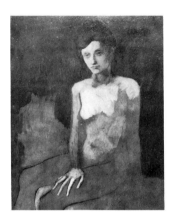

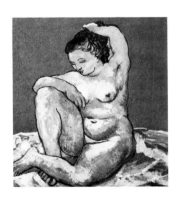

NUDE WITH HAIR PULLED BACK
page 31
Paris, 1905
Gouache on cardboard
Size: 21⅝ x 19⅜ inches
Signed bottom right: ?
Present location unknown

THE TWO GIANTS *page 28*
Paris, 1905
India ink on paper
Size: 11½ x 8¾ inches
Signed bottom right: Picasso
(Note: The signature is later)
Coll. Jan Krugier, Geneva

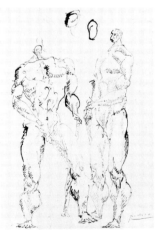

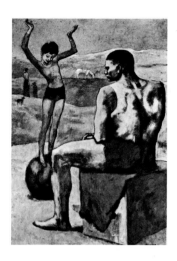

YOUNG ACROBAT ON A BALL
page 16
Paris, 1905
Oil on canvas
Size: 57⅞ x 37⅜ inches
Signed bottom right: Picasso
Coll. The Pushkin Museum, Moscow

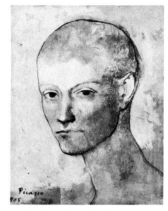

HEAD OF A YOUNG MAN *page 34*
Paris, 1905–1906
Gouache on cardboard
Size: 12¼ x 9½ inches
Signed and dated bottom left:
Picasso, 1905
Coll. The Cleveland Museum of Art,
Bequest of Leonard C. Hanna, Jr.

YOUNG MAN ON A
SUNDAY WALK *page 44*
Paris, 1905
Size: 11 x 16¾ inches
Signed bottom left: Picasso
(Note: The signature is later)
Coll. Mr. and Mrs. John D. Schiff,
New York

BOY ON HORSEBACK
(and other sketches) *page 45*
Paris, 1906
Pen on paper
Size: 16 x 12¾ inches
Signed bottom left: Picasso
Dated top left: P. 06
(Note: The signature is later)
Private Collection, New York

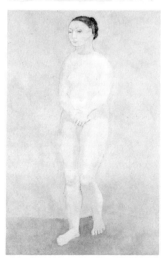

GRAND ROSE NUDE *page 45*
Gosol, Summer 1906
Oil on canvas
Size: 60¼ x 37 inches
Unsigned
Coll. Mr. and Mrs. William S. Paley,
New York

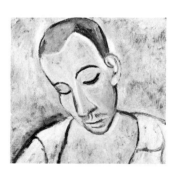

HEAD OF A SAILOR *page 34*
Paris, 1905–1906
Oil on canvas
Size: 15¾ x 16⅝ inches
Unsigned
Coll. Mr. and Mrs. David Rockefeller,
New York

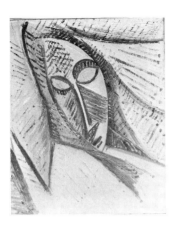

HEAD OF A WOMAN *page 33*
Paris, 1906
Oil on canvas
Size: 23⅞ x 18¼ inches
Unsigned
*Coll. Mr. and Mrs. John Hay
Whitney, New York*

Note: This is a study for the *Nude With Drapery* now in Leningrad. In addition to owning the picture itself and this study Miss Stein owned at least four additional studies.

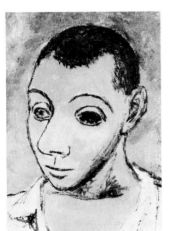

HEAD OF A YOUNG MAN *page 55*
Paris, Autumn 1906
Oil on canvas
Size: 10¾ x 7¾ inches
Unsigned
Coll. Mr. André Meyer, New York

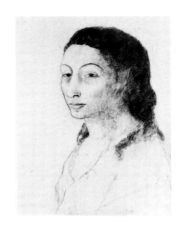

HEAD OF FERNANDE *page 60*
Gosol, 1906
Charcoal on paper
Size: 612 x 458 mm.
Signed lower right: Picasso
*Coll. Art Institute of Chicago,
Gift of Herman Waldeck*

Note: In a letter to a friend dated March 4, 1958, Miss Toklas offered the following comment on Fernande:

When Picasso first saw Gertrude Stein at Sagot's and asked her to sit for him, Fernande had been living with him for about two years. She was extremely beautiful in an Arabian Nights way, with long almond eyes, [it is those eyes which are the inspiration for the Grand Rose Nude—ed.] and she had the most beautiful speaking voice.

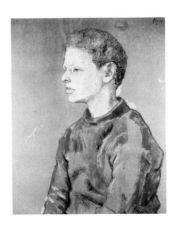

PORTRAIT OF ALLAN STEIN
page 34
Paris, 1906
Gouache
Size: 29⅛ x 23½ inches
Signed top right: Picasso
*Coll. The Baltimore Museum of Art,
Cone Collection*

Note: This picture belonged to Michael Stein, Gertrude Stein's brother.

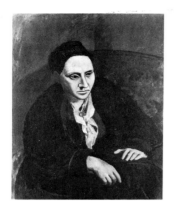

PORTRAIT OF GERTRUDE STEIN
page 25
Paris, Autumn 1906
Oil on canvas
Size: 39⅜ x 32 inches
Unsigned
Coll. The Metropolitan Museum of Art, New York. Bequest of Gertrude Stein, 1946

Note: Miss Stein has told how "Picasso sat very tight in his chair and very close to his canvas and on a very small palette which was of a uniform brown-gray color began mixing some more brown-gray." This first sitting was followed by about ninety more. Picasso, despairing of ever finishing the portrait, for he was not satisfied with the face, one day blocked out the entire head. The portrait remained half-painted. Some months later on his return from Gosol, he took up the canvas and finished it in the absence of Gertrude Stein. Examination of the painting with the aid of X rays reveals that the original head was framed somewhat higher to the right and was markedly less sculptural.

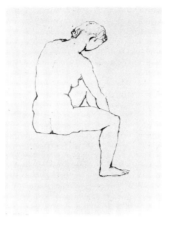

SEATED NUDE *page 46*
1906
Pen on paper
Size: 7⅞ x 5½ inches
Signed top right: Picasso
(Note: The signature is later.)
Coll. Mr. and Mrs. Richard K. Weil, St. Louis, Missouri

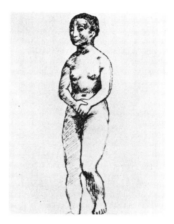

STANDING NUDE, HANDS CLASPED *page 60*
Gosol, Summer 1906
Conté crayon on paper
Size: 24½ x 18⅝ inches
Signed bottom left: Picasso
Coll. Mr. and Mrs. Leigh B. Block, Chicago

Note: This is one of two studies for the *Grand Rose Nude* owned by Leo and Gertrude Stein, the other is now in the Barnes Collection.

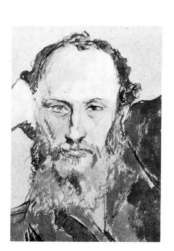

PORTRAIT OF LEO STEIN *page 55*
Paris, Spring 1906
Gouache
Size: 9¾ x 6¾ inches
Unsigned
Coll. The Baltimore Museum of Art, Cone Collection

Note: Even after Leo and Gertrude Stein no longer shared a studio together, this picture remained as part of Gertrude's collection. Miss Etta Cone purchased the portrait from Gertrude Stein in 1932.

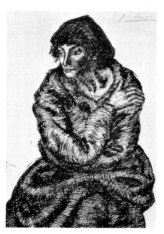

SEATED NUDE WITH FOLDED ARMS *page 55*
1906
Pen on paper
Size: 16⅛ x 11-13/16 inches
Signed bottom left: Picasso
(Note: The signature is later)
Coll. Mr. and Mrs. Richard K. Weil, St. Louis, Missouri

STUDIES FOR "TWO NUDES"
page 45
Paris, Autumn 1906
Conté crayon on paper
Size: 24 x 17¾ inches
Signed bottom left: Picasso
Coll. The Museum of Fine Arts,
Boston. Arthur Tracy Cabot Fund

Note: This sketch is a study for the *Two Nudes* now in the collection of the Museum of Modern Art, New York.

THE SWINEHERD *page 30*
1906
Ink with added pencil
Size: 8¼ x 7⅞ inches
Signed upper right: Picasso
(Note: The signature is later)
Coll. Mr. and Mrs. Daniel Saidenberg,
New York

STUDY FOR "TWO YOUTHS"
page 46
Gosol, Summer 1906
Crayon mounted on cardboard
Size: 10⅛ x 7 inches
Unsigned
Private Collection, New York

Note: This is a study for the picture *Two Youths* now in the National Gallery, Chester Dale Collection, Washington, D.C.

TWO NUDES *page 34*
Paris, Autumn 1906
Gouache, charcoal, and watercolor
Size: 25 x 19⅛ inches
Signed upper left: Picasso
Coll. The Baltimore Museum of Art,
Cone Collection

STUDY FOR "WOMAN
WITH LOAVES" *page 47*
Gosol, Summer 1906
Pencil on paper
Size: 23¾ x 15¾ inches
Signed bottom left: Picasso
Present location unknown

Note: The *Woman With Loaves* is in the Philadelphia Museum of Art.

STUDY FOR "NUDE WITH
DRAPERY" *page 67*
Paris, 1907
Oil on paper mounted on canvas
Size: 12¼ x 9½ inches
Unsigned.
Coll. Mr. and Mrs. Lionel Steinberg,
Thermal, California

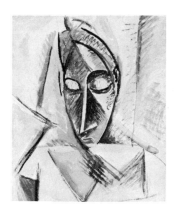

HEAD *page 67*
Paris, 1907
Oil on paper
Size: 12¼ x 9½ inches
Unsigned.
Private Collection, New York

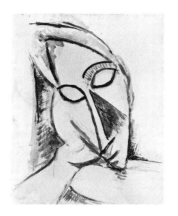

HEAD IN BROWNS AND BLACK
page 66
Paris, 1907
Oil on paper
Size: 12¼ x 9½ inches
Unsigned
Private Collection, New York

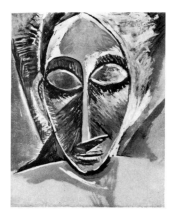

HEAD *page 32*
Paris, 1907
Oil and tempera on paper mounted on board
Size: 12¼ x 9½ inches
Unsigned
Private Collection, New York

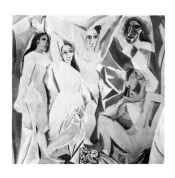

LES DEMOISELLES D'AVIGNON
page 58
Spring, 1907
Oil on canvas
Size: 8 feet x 7 feet 8 inches
Unsigned
Coll. The Museum of Modern Art, New York. Acquired through the Lillie P. Bliss Bequest

Note: This picture was not part of the Stein Collection.

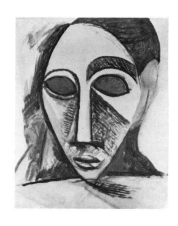

HEAD *page 66*
Paris, 1907
Oil on paper
Size: 12¼ x 9½ inches
Unsigned
Private Collection, New York

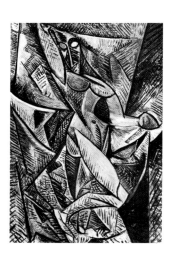

NUDE WITH DRAPERY *page 58*
Paris, Summer 1907
Oil on canvas
Size: 61 x 38½ inches
Unsigned
Coll. The Hermitage, Leningrad

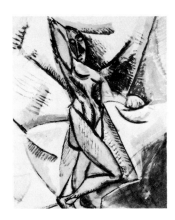

NUDE WITH RAISED ARM
page 58
Paris, 1907
Watercolor
Size: 12¼ x 9½ inches
Unsigned
Coll. The Baltimore Museum of Art,
Cone Collection

Note: This picture is a study for the
Nude With Drapery.

STILL LIFE: GLASSES AND FRUIT
page 64
Paris, Winter 1908
Oil on panel
Size: 10⅝ x 8½ inches
Unsigned
Private Collection, New York

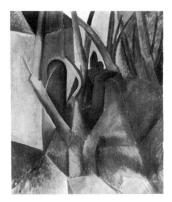

GREEN LANDSCAPE *page 57*
1908
Oil on canvas
Size: 39⅝ x 32 inches
Unsigned
Coll. Mr. and Mrs. David Rockefeller,
New York

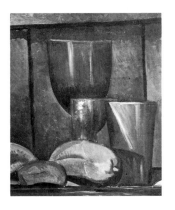

GLASSES AND FRUIT *page 64*
Paris, 1908
Oil on panel
Size: 10⅝ x 8⅜ inches
Unsigned
Private Collection, New York

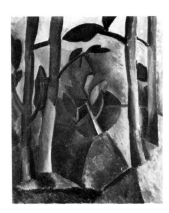

LA RUE DE BOIS
(pres Verneuil, Oise) *page 101*
1908
Oil on canvas
Size: 27⅞ x 23¾ inches
Unsigned
Coll. Mr. André Meyer, New York

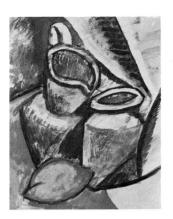

STILL LIFE WITH LEMON *page 64*
Paris, 1908
Oil on paper
Size: 12⅞ x 9½ inches
Unsigned
Coll. Mr. and Mrs. David Rockefeller,
New York

STILL LIFE WITH PEARS *page 73*
Paris, Winter 1908
Oil on canvas
Size: 10⅝ x 8⅜ inches
Unsigned
Coll. Mr. and Mrs. John Hay
Whitney, New York

HOMAGE TO GERTRUDE *page 100*
Paris, 1909
Tempera on wood
Size: 8¼ x 10¾ inches
Unsigned
Private Collection, New York

Note: This painting was originally intended to be tacked onto the ceiling directly above Gertrude Stein's bed. When Miss Stein moved in 1937 from 27, rue de Fleurus to 5, rue Christine, the picture rested on the fireplace in her bedroom.

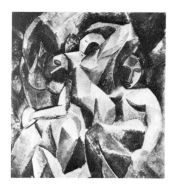

THREE WOMEN *page 80*
Paris, 1908
Oil on canvas
Size: 78¾ x 70⅛ inches
Unsigned
Coll. The Hermitage, Leningrad

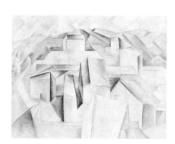

MAISONS SUR LA COLLINE,
HORTA DE EBRO *page 39*
Summer, 1909
Oil on canvas
Size: 25⅝ x 32 inches
Unsigned
Private Collection, New York

Note: In *The Autobiography of Alice B. Toklas* Miss Stein writes about this picture and the picture *The Reservoir, Horta de Ebro:*
That summer they [Picasso and Fernande] went again to Spain and he came back with some spanish landscapes and one may say that these landscapes, two of them still at the rue de Fleurus . . . were the beginning of cubism. In these there was no african sculpture influence. There was very evidently a strong Cézanne influence, particularly the influence of the late Cézanne water colours, the cutting up the sky not in cubes but in spaces.
But the essential thing, the treatment of the houses was essentially spanish and therefore essentially

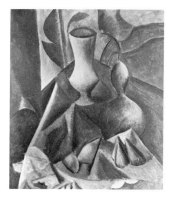

GREEN STILL LIFE *page 81*
Paris, Spring 1909
Oil on canvas
Size: 28½ x 23⅜ inches
Unsigned
Coll. Mr. and Mrs. John Hay
Whitney, New York

Picasso. In these pictures he first emphasised the way of building in spanish villages, the line of the houses not following the landscape but cutting across and into the landscape, becoming undistinguishable in the landscape by cutting across the landscape.

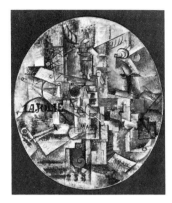

THE ARCHITECT'S TABLE *page 56*
Paris, Spring 1912
Oil on canvas (oval)
Size: 28⅝ x 23½ inches
Unsigned
Coll. Mr. and Mrs. William S. Paley, New York

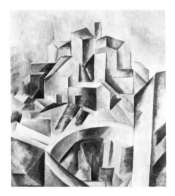

THE RESERVOIR, HORTA DE EBRO
page 49
Summer, 1909
Oil on canvas
Size: 23¾ x 19¾ inches
Unsigned
Coll. Mr. and Mrs. David Rockefeller, New York

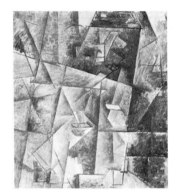

THE LITTLE GLASS *page 81*
Paris, Spring 1912
Oil on canvas
Size: 18¼ x 15⅛ inches
Unsigned
Private Collection, New York

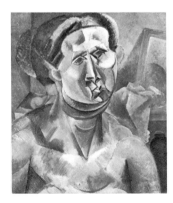

WOMAN WITH MIRROR
(Portrait of Fernande) *page 80*
Paris, 1909
Oil on canvas
Size: 23⅞ x 20-3/16 inches
Unsigned
Coll. The Art Institute of Chicago, Joseph Winterbotham Collection

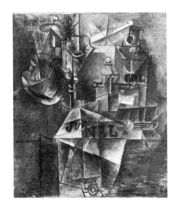

STILL LIFE (Journal) *page 63*
Paris, Spring 1912
Oil and charcoal on canvas
Size: 18¼ x 15¼ inches
Unsigned
Coll. Mr. and Mrs. John Hay Whitney, New York

STUDY FOR "THE VIOLIN" *page 84*
Paris, Winter 1912
Crayon and charcoal on paper
Size: 18⅝ x 24⅝ inches
Unsigned
Coll. Marlborough Gallery, New York

STUDY FOR "GUITAR ON TABLE"
page 84
Paris, 1912–1913
Crayon drawing
Size: 19⅛ x 25 inches
Unsigned
Coll. Marlborough Gallery, New York

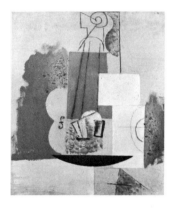

THE VIOLIN *page 84*
Paris, Winter 1912
Oil, sand and charcoal on canvas
Size: 21¾ x 17 inches
Unsigned
Private Collection, New York

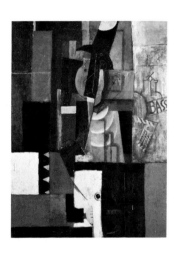

MAN WITH A GUITAR *page 89*
Paris, 1913
Oil and wax on canvas
Size: 51¼ x 35 inches
Unsigned
Coll. Mr. André Meyer, New York

Note: In 1913 Stein sold three early Picasso paintings to her friend Mr. Daniel-Henry Kahnweiler: *Young Acrobat on a Ball* (now Pushkin Museum, Moscow), *Three Women*, and *Nude With Drapery* (both now The Hermitage, Leningrad). This work was purchased with the money from that sale.

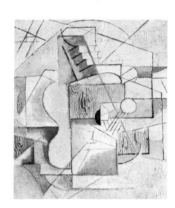

GUITAR ON TABLE *page 84*
Paris, 1912–1913
Oil, charcoal, and sand on canvas.
Size: 24¼ x 20 inches
Unsigned
Private Collection, New York

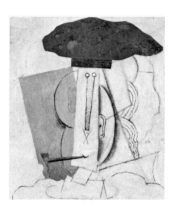

STUDENT WITH A PIPE *page 87*
Paris, Winter 1913–1914
Oil, charcoal, pasted paper, and sand on canvas
Size: 28¾ x 23⅛
Unsigned
Private Collection, New York

Note: The now-dark béret was, according to microscopic examination, at one time red.

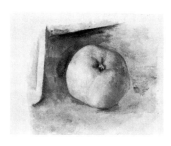

APPLE *page 97*
Paris, 1914
Watercolor
Size: 5⅜ x 6⅞ inches
Unsigned
Inscribed on back: "Souvenir pour Gertrude et Alice / Picasso / Noel / 1914"
Coll. Mr. and Mrs. David Rockefeller, New York

Note: The history of *Apple* is intertwined with the final break between Leo and Gertrude Stein late in 1913. In *Journey into the Self*, Leo gives an account of what this breakup meant in terms of the collection.
The Cézanne apples have a unique importance to me that nothing can replace. The Picasso landscape is not important in any such sense. We are . . . both so well off now that we needn't repine. The Cézannes had to be divided. I am willing to leave you the Picasso Oeuvre, as you left me the Renoir, and you can have everything except that. I want to keep the few drawings that I have. This leaves no string for me, it is financially equable either way for the estimates are only rough and ready methods, and I'm afraid you'll have to look upon the loss of the apples as an act of God.
It is clear that Cézanne's *Still Life with Apples* had deep meaning for both the Steins. According to Alice B. Toklas, Gertrude was so distressed at this loss that Picasso, in an effort to cheer her, said, "I will paint you one apple and it will be as fine as all of Cézanne's apples." He presented this lone apple to Gertrude and Alice at Christmas 1914.

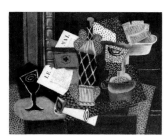

STILL LIFE (Verre, Bouteille Rhum Paillée, Compotier sur une table) *page 88*
Avignon, 1914
Oil and charcoal on canvas
Size: 15 x 18⅛ inches
Signed and dated bottom right: Picasso / 1914
Coll. Mr. and Mrs. John Hay Whitney, New York

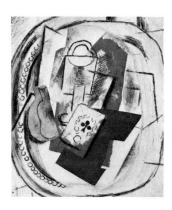

STILL LIFE WITH ACE OF CLUBS
page 87
Paris, 1914
Oil, pencil, charcoal, and pasted paper on panel
Size: 15 x 17⅞ inches
Unsigned
Coll. Mr. and Mrs. John Hay Whitney, New York

STILL LIFE WITH CALLING CARD
page 104
Paris, 1914
Pencil and pasted papers on paper
Size: 5½ x 8¼ inches
Unsigned
Coll. Mrs. Gilbert W. Chapman, New York

Note: According to Miss Toklas, she and Miss Stein visited Picasso, found he was not in, and left their card. (The turned-down edge indicates that they had personally been there.) When Picasso returned, he picked up the card and tore off the fold. A few days later when he again picked up the card to use in a collage, he drew in the fold. The picture was left at 27, rue de Fleurus sometime later as Picasso's calling card. Neither Miss Stein nor Miss Toklas were at home.

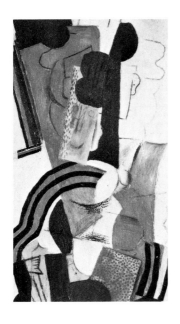

WOMAN WITH MANDOLIN
(with Russian Letters) *page 87*
Paris, 1914
Oil, sand, and charcoal on canvas
Size: 45½ x 18¾ inches
Unsigned
*Coll. Mr. and Mrs. David Rockefeller,
New York*

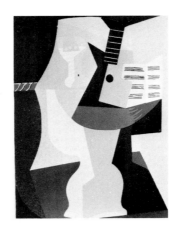

TABLE WITH GUITAR
AND PARTITION *page 102*
Juan Les Pins, 1920
Gouache mounted on cardboard
Size: 10⅜ x 8¼ inches
*Signed on the cardboard bottom left:
Picasso*
*Coll. Mr. and Mrs. Gilbert W.
Chapman, New York*

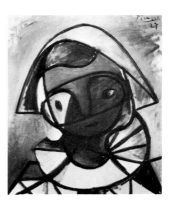

PORTRAIT OF THE ARTIST'S SON
page 102
1927
Oil on canvas
Size: 21⅞ x 9⅝ inches
*Signed and dated upper right:
Picasso / 27*
Coll. of the artist

Note: This picture was never part of
the Stein Collection.

GUITAR *page 102*
Paris, 1918
Watercolor
Size: 6¾ x 7½ inches
Unsigned
*Inscribed on back upper left:
"pour Gertrude Stein / son ami
Picasso / Montrouge 26 Avril 1918"*
*Coll. Mr. and Mrs. David Rockefeller,
New York*

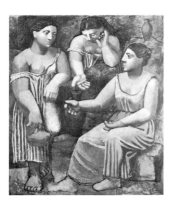

THREE WOMEN AT THE SPRING
page 104
Summer 1921
Oil on canvas
Size: 80¼ x 68½ inches
*Signed and dated lower right:
Picasso / 21*
*Coll. The Museum of Modern Art,
New York. Gift of Mr. and Mrs.
Allan D. Emil*

Note: This picture was never part of
the Stein Collection.

CARL SANDBURG COLLEGE
Ge..... Stein ... Picasso. Steinrtr
ST....

14491 14491
 ND 553 •P5 S76

ND.
553 WITHDRAWN STEIN G
•P5
S76 GERTRUDE STEIN ON PICASSO

Sandburg College
Learning Resources Center
Galesburg, IL 61401